a comprehensive guide to digital photographic output

AVA Publishing SA
Switzerland

An AVA Book
Published by AVA Publishing SA
Chemin de la Joliette 2
Case postale 96
1000 Lausanne 6
Switzerland
Tel: +41 786 005 109
Email: enquiries@avabooks.ch

Distributed by Thames & Hudson (ex-North America)
181a High Holborn
London WC1V 7QX
United Kingdom
Tel: +44 20 7845 5000
Fax: +44 20 7845 5055
Email: sales@thameshudson.co.uk
www.thamesandhudson.com

Distributed by Sterling Publishing Co., Inc.
in the USA
387 Park Avenue South
New York, NY 10016-8810
Tel: +1 212 532 7160
Fax: +1 212 213 2495
www.sterlingpub.com

in Canada
Sterling Publishing
c/o Canadian Manda Group
One Atlantic Avenue, Suite 105
Toronto, Ontario M6K 3E7

English Language Support Office
AVA Publishing (UK) Ltd.
Tel: +44 1903 204 455
Email: enquiries@avabooks.co.uk

ISBN 2-88479-075-6

10 9 8 7 6 5 4 3 2 1

Design: Bruce Aiken
Picture research: Sarah Jameson

Production and separations by
AVA Book Production Pte. Ltd., Singapore
Tel: +65 6334 8173
Fax: +65 6334 0752
Email: production@avabooks.com.sg

a comprehensive guide to digital photographic output

duncan evans

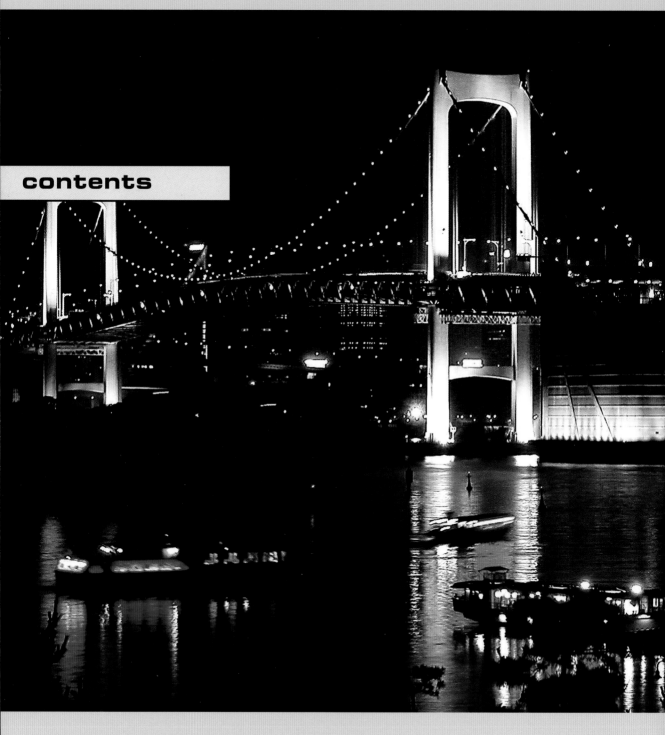

contents

The Rainbow Bridge in Tokyo by Duncan Evans.

6 introduction
8 how to get the most from this book

1 image definition
12 camera resolution and colour
14 image size and interpolation
18 print sizing

2 electronic output
22 file formats
24 images for the web
26 email and ftp transmission
28 output pdf

3 colour modes and profiles
32 rgb
34 cmyk
36 lab colour
38 colour profiles
40 colour space conversion
42 converting to mono

4 calibration
46 calibrating your monitor
48 printer and paper scanning
50 setting up photoshop

5 printers for photography
54 inkjets for the home
56 event printing

6 commercial printing
60 high street and on-line printing
62 specialist labs
64 unusual print options

7 colour inkjet printing
68 colour management
70 printer driver options
72 creating a test print
74 exif and pictbridge
76 print image matching

8 mono inkjet printing
80 printing in mono
82 printer driver options
84 colour cast solutions

9 alternative ink systems
88 alternative blacks
90 colour inks

10 paper types
94 colour and mono papers
96 art effect papers

11 digital effects
100 duotoning
102 boost colour saturation
104 high key effect
106 texture effects
108 grainy pictures
110 spot colour
112 panoramas

12 frame it up
116 get the edge
118 making your own edges
120 adding frames
122 creating frames

13 storage and display
126 backing up
128 self-displaying pictures
130 creating videocd/dvd
132 digital projectors

appendix
136 glossary
140 contacts
144 acknowledgements

introduction

One of the revolutionary aspects of digital imaging is that it has freed the digital photographer from the necessity of having photos printed before they can be seen. Now, pictures can be previewed in-camera and examined, modified and enhanced on computer. Only those that really make the grade are then printed out. This, however, is where the problems start for many. A monitor is a back-lit, light emitting device, whereas a print is a reflective surface and as a result, what you see on the monitor will never look exactly the same as what you see in print. However, the problems come when the image on screen looks fine but the print is too dark, the colours are all wrong or there are strange casts ruining black-and-white prints. And that's just the colours. In the hands of the unwitting, pictures can be printed at too low a resolution resulting in jagged edges and lack of detail, or the camera might not produce a big enough file size to use how you want. The picture could be lacking punch, be weakly saturated. There are a host of reasons why the final print might not match your vision and that's where this book comes in.

In Digital Photographic Output, specifically written for digital photographers, we cover image resolution, print sizes and digital camera resolution. Then, if your picture isn't big enough, there's interpolation and what's feasible and what's not. Preparing your pictures for electronic output is essential. The basics of levels, curves and sharpening are discussed, before file formats, saving for the web and email, and outputting PDFs are covered. Learn how to trade file size against quality loss.

Colour modes determine how your image looks but more importantly, are used for specific output purposes. Know what they're needed for and how to use colour profiles that are embedded into an image. Whether your software is Photoshop, Elements or PSP, embedding a colour profile will help retain the integrity of its colour information. Set up your software to use colour profiles, then calibrate the monitor to use the same profile before moving on to the output from the printer and tying it all together to get an integrated system.

Digital photographers like to print their own work – it's a fact. Discover which printer types you need for what kind of work you'll be doing. Know that a three-ink system is a waste of time if you are serious about your prints. If it's too much trouble or too expensive, see what commercial printing has to offer.

Then it's time to get practical. See what your printer driver has to offer, how you can make the prints better and more accurate, and what you can do when the colours still don't look right. And if that's a problem for colour printing, colour casts are the bugbear of mono inkjet work. This book offers up suggestions for sorting these out. The more serious you get, the more alternative ink systems start to become attractive. We look at replacement mono and colour systems.

Output relies on your choice of paper. This book examines a selection of paper types and what they are good and not so good for. In the chemical darkroom the dedicated printer can produce all manner of effects as the print is being developed. In the digital darkroom you can achieve all the same effects and more. In this chapter a variety of printing effect types and processing options are demonstrated, all before your digital image gets near the printer, and without affecting the original image. Being digital we can also add edge effects without a care in the world and if you don't have a lavish frame to mount your image, just create one digitally instead.

The final chapter looks at the important issues of storage and electronic display. You need to secure those images against hard drive failure, and discover how to package them for display on CD or DVD on the television in your living room.

Digital photographic output isn't just a dry, dull subject for overbearing technocrats, it's the essential skill in turning your digital image from on-screen vision to a glorious printed reality that you can hang on the wall. Whether you want a totally integrated system or just some ideas for getting better quality prints, Digital Photographic Output is the book you can't do without.

Duncan Evans LRPS

how to get the most from this book

This book is divided into 13 chapters. These chapters cover subjects such as image definition, electronic output, colour modes and profiles, calibration, printers and printing, ink systems, paper types, digital effects, framing images, and finally storage and display. The appendix includes a useful glossary of technical terms together with the photographers' biographical details.

The featured work comes from both professional photographers and talented enthusiasts, and there is something for everyone no matter what their approach or starting point.

introduction

An overview of the theme and techniques set out in the spread.

flow chart

A step-by-step outline of the main stages that the image has gone through is given in a flow chart. This allows a quick reference to the same or similar points of interest on different spreads. The flow chart also enables the reader to determine at a glance how simple or complex was an image was to create.

! Old people, ruined, deserted buildings or farms all make great subjects for dirty, grainy pictures.

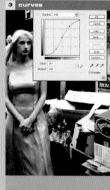
1

! Ensure the grain effect is strong enough to be readily noticeable, otherwise it will be mistaken for digital noise.

grainy pictures

If you want to produce grainy, contrasty black-and-white pictures and you use film, it's easy. All you have to do is go and find a black-and-white film that has lots of contrast and offers a high ISO like 3200, which guarantees plenty of grain. When shooting digitally, there's no such option – though in my mind camera manufacturers should certainly give you it. Don't be misled into thinking that simply ramping up the ISO on your digital camera will give you a similar, grainy effect. It won't. High digital ISOs produce coloured noise and in most cases, loss of detail. Even once that coloured noise has been converted to mono, the lack of detail will be apparent. Instead, do it in Photoshop or your favourite software package.

> digital capture
> crop
> channel mixer
> curves adjustment layer
> grain filter
> channel mixer
> interpolation
> save as TIFF
> alternative edge effect

108 digital effects

shoot

It was an early evening round the corner from Chinatown in London's west end. The model was wearing a ballgown while I was wielding a digital SLR as we hunted for rubbish and the detritus of modern, city life. The juxtaposition of posh outfit with low-life grime, then turned into a black-and-white, gritty picture would make a photographic statement. Aside from dodging taxis, the problem was that the light wasn't very bright. Good enough for ISO 100, but only with the aperture wide open at f2 on this camera. The focus was placed on the background, to give the model a disconnected feel by being slightly out of focus thanks to the shallow depth of field.

enhance

To concentrate the viewers' attention on the model, the picture was first cropped to remove extraneous detail. Then, it was converted to mono using the channel mixer option. The greyscale box was ticked and the RGB channels adjusted to get the best contrast picture (2).

2 **channel mixer**

Output Channel: Gray

Source Channels
Red: +40 %
Green: 40 %
Blue: 20 %

Constant: 0 %

☑ Monochrome

OK
Cancel
Load...
Save...
☑ Preview

3 **curves**

Channel: RGB

Input: 181
Output: 208

To get the really striking contrast required for the picture the curves tool was needed (3). However, used on its own, the white of the boxes of rubbish had all their detail blown out. The solution was to use a curves adjustment layer. The curve was applied and then the boxes in the layer painted over with black to mask the effect.

Next the grain filter was applied with an intensity of 40 (4). This is very strong, but it is also colour. When the channel mixer was used again to turn this colour noise to mono, the effect becomes more pronounced. As the picture was cropped in the first place, it needed to be resized to make it a higher resolution. The secondary effect of doing this now rather than at the start, was that the grain effect was

! Perform high contrast adjustments on the desktop where you will have total control, not as a camera option.

section title

images

The images in this book feature popular subjects such as landscapes, portraits, nudes and still lifes. We also showcase the ever-expanding genre of 'conceptual' images. All these types of subject matter have their place in modern image-making and, from the traditional to the surreal, there are examples of images for people of all tastes to appreciate.

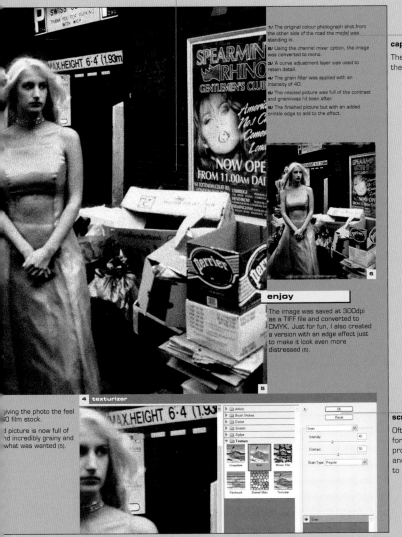

1/ The original colour photograph shot from the other side of the road the model was standing in.

2/ Using the channel mixer option, the image was converted to mono.

3/ A curve adjustment layer was used to retain detail.

4/ The grain filter was applied with an intensity of 40.

5/ The resized picture was full of the contrast and graininess I'd been after.

6/ The finished picture but with an added crinkle edge to add to the effect.

captions

The image captions clarify and recap the processes shown in each image.

enjoy

The image was saved at 300dpi as a TIFF file and converted to CMYK. Just for fun, I also created a version with an edge effect just to make it look even more distressed (6).

giving the photo the feel 0 film stock.

d picture is now full of nd incredibly grainy and what was wanted (5).

screengrabs

Often detailing the exact settings used for key stages of the photo-editing process, screengrabs provide a quick and instructive visual check with which to follow the proceedings.

photographers

Alec Ee
Duncan Evans

1 image definition

Understanding picture resolution and colour creation is vital in the world of digital imaging. Image size is central to all output questions where the requirements of the subject area set the definition required. This chapter explains how pictures can be defined and interpolated and the print density you will need for any set of circumstances.

Alec Ee from Singapore took this picture using a Nikon digital SLR and an 18–70mm medium telephoto zoom lens. He was in the Zion National Park in California, USA, when he spotted this rock formation and shot it using the Adobe RGB colour workspace.

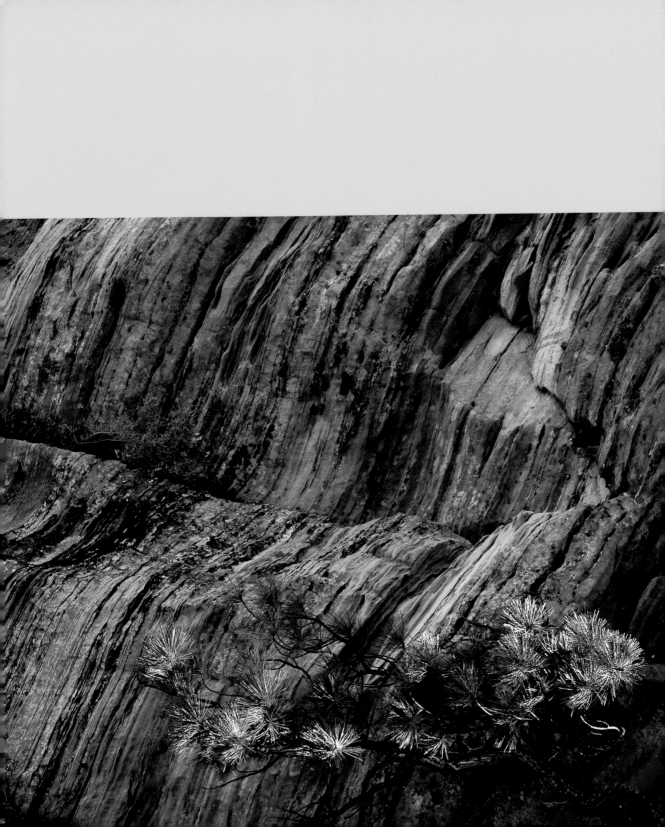

camera resolution and colour

For photographers using digital cameras, resolution is simply an updating of the question that film photographers have had to ask themselves for years. How much is enough? For film, the choice is between **APS**, **35mm**, medium format (in its three flavours) and large format. **APS is a happy-snapper format, and as such has been severely affected by inexpensive digital cameras, to the extent that a number of companies have stopped making it and APS format cameras. Serious photographers would only consider the other formats, which increase in negative size, offering greater reproduction possibilities and detail, but decreasing in flexibility, portability and speed.**

> digital capture
> hue/saturation
> unsharp mask
> print and frame
> converted to CMYK

cameras

Digital cameras come in a number of different shapes and sizes, but can be boiled down to a few categories: style cameras, compacts, semi-pro compacts and SLRs. It is the latter two that are the most useful for serious photography, but not just because of the resolutions they offer. Speed of shooting, availability of functions and lens quality are all better, with SLRs offering the best quality and performance. Which leads to resolution. The current crop of semi-pro compacts all feature 8Mp chips, which is more than some of the SLRs – the consumer SLRs – which currently have around 6Mp, rising to 10Mp and 14Mp for more expensive pro models. However, in digital, simple resolution does not, unlike film, necessarily equate to more detail and better quality.

The chips used in compact cameras are smaller than those in SLRs, therefore the signal-noise ratio is higher. The diodes are more closely packed, requiring greater quality of light distribution, but the lenses are inferior to those on an SLR, which all leads to poorer quality images.

In film cameras, the film dictates how much information can be recorded, but the lens is responsible for how well it is recorded. In digital, sensor size is important, but lens quality is vital. Opposite is a table showing what kind of camera and resolution are required as a minimum for various types of picture.

shoot

The image opposite is a ruined croft and outcropping of rock with spring flowers, taken with a 6Mp digital SLR using an f22 aperture for maximum depth of field. This scene is fairly easy for a camera to evaluate as it has clearly defined areas of green and blue indicating a landscape. However, it still required a little tweaking.

colour accuracy

There is one sensor type, made by Foveon, that uses three layers above the sensor to detect red, green and blue elements, leading to more accurate colour representation. Apart from that, virtually all other digital cameras use one colour-detection matrix that consists of repeating patterns of red, blue and two green sensors. Only when the final image has been recorded does the camera firmware evaluate the picture type and tries to adjust the colour readings so that it is as accurate as possible. This is prone to error if the picture type isn't immediately obvious. Swathes of green followed by a strip of blue is obviously a landscape and the camera can adjust accordingly. Someone stood in front of the camera is another easy subject to identify, but others may not be, leading to colour bleeding along edges of objects. The test of a good sensor and firmware combination is how well it interprets the images and corrects the colours. Early Fuji and Sony cameras were notorious for nuclear shades of red and strange pink-tinged skies. These days only the cheapest digital camera will give you bad colour

Picture type	Camera required	Resolution required
Family snapshots	Compact	1Mp
Family photos to frame	Compact	2Mp
A4 family photos	Compact	3Mp
Macro photos	Semi-pro compact	4Mp
Portraits	Semi-pro compact	4Mp
Large portraits	Semi-pro compact	5Mp
Pro studio portraits	SLR	5Mp
General landscapes	SLR	6Mp
Large format landscapes	SLR	8Mp + interpolation

! Camera resolution isn't an absolute indicator of final picture quality and detail – look at the entire system including the lens.

enhance

The sky was a little flat on the original so hue/saturation was selected, the blue range chosen and the colour picker used to narrow the colour selection right down. Then the saturation was increased by 11%. Unsharp mask was also used to sharpen the image up.

enjoy

The image was printed out with a border and framed on the wall of my house. It was also converted to CMYK for use here.

The final image has plenty of saturation and sharpness, and thanks to a 6Mp resolution, a good amount of detail.

1/ Hue/saturation was selected. The blue range was chosen and the saturation was increased by 11%.

2/ The final image. Thanks to a 6Mp resolution, there is a lot of detail. Saturation and sharpness are strong too.

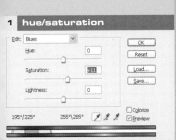

1 hue/saturation

| Edit: Blues |
| Hue: 0 |
| Saturation: 11 |
| Lightness: 0 |

OK
Reset
Load...
Save...

195°/225° 255°\285° ☐ Colorize ☑ Preview

reproduction across the board, but others vary in how precise they are.

You can also generalise across ranges of cameras, because the designers use the same evaluation criteria in each one. Fuji cameras will always give you healthy looking people, Nikon cameras have a tendency to give very neutral results while some Olympus cameras will give bright blue skies. Certainly the newest Olympus SLR, the E-1, has incredibly accurate and punchy colour reproduction.

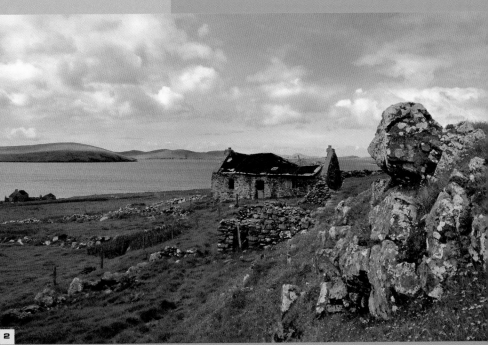

2

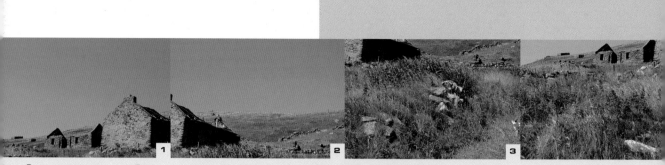

1 2 3

image size and interpolation

The number of individual picture elements, or pixels, in a photo, whether it comes from a digital camera or is scanned from film, determines the amount of detail in an image. For pictures such as portraits, fewer pixels are needed, for two reasons: the first is that the human eye recognises the shape of another person automatically, and also reads emotion from that picture. The viewer attaches a meaning or an interpretation to what they are looking at. The second is that unless the resolution is so low that jagged edges are visible, the eye is not looking for every tiny piece of skin on the face or body of the subject, so smoother looking portraits, with less detail, are perfectly acceptable. It's a similar effect to using fine ISO 200 or 400 film for portraits. With the right film, grain isn't noticeable at these ratings, yet because the grain is bigger, fewer flaws show up on the portrait. Unfortunately, higher digital ISO doesn't work the same way, it just produces more random colour noise in an image.

Where pixels and detail really count are in landscape photography, or to some extent macro work, where not only is the subject full of detail that needs revealing itself, but the viewer comes to the photo looking for that detail as well. This is one of the reasons that professional landscape photographers use medium or large format rather than 35mm – there is much more detail available. Digital is roughly equivalent to 35mm film, so for landscape work, more detail is usually appreciated. Macro work can get away with the resolutions offered by high-spec consumer cameras for the simple reason that often a wide aperture is used, rendering the rest of the photo out of focus anyway. As long as the main point of interest is in sharp focus, you can produce perfectly fine macro work with as little as 3Mp resolution.

There are two ways of increasing the detail and size of a picture – one is to take multiple pictures and join them together. Usually this technique is used to create panoramas, but is equally valid for simply producing a more detailed digital picture. The photo on this page shows how to do it.

shoot

Here we are on a nice sunny day shooting a deserted croft house. A standard picture with my Fuji digital SLR produces a result of 3024*2016, or a 6Mp resolution file. Good, but for landscapes you may need a little more detail. So, the camera was mounted on a tripod and focus was locked on the buildings, then set to manual. I used the short zoom to double the size of the image in the viewfinder, then recomposed to the left and the top quarter of the new prospective image. The camera was swung to the right, with a little overlap for the second shot, then lowered down for the bottom right-hand corner, again with overlap. Finally, it was swung left to the bottom left corner for the final part (1/2/3/4).

enhance

The first picture in the series was loaded and then Image > Canvas Size selected (5). The canvas size was increased by doubling the dimensions in both directions. Then all the other pictures in the series were loaded as separate layers.

The first task was to fit all the pieces together, maximising the joins so that the least amount of work needed to be done. Clear skies are the easiest to join

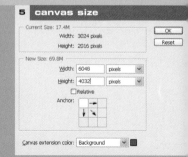

5 canvas size

together so the image layers were moved around to make this the case (6). The line down

1/2/3/4/ The individual pictures that went into creating the final, super high-resolution image.

5/ The canvas size was decreased by doubling the dimensions in both directions.

6/ Each picture was loaded as a separate layer and then each piece needed to be fitted together. Clear skies are the easiest to join together so the image layers were moved around to make this the case.

7/ Levels and curves were used on each layer to make them as close to each other as possible. Note the sky shown here.

! Landscapes need as much detail as possible. If you are using a camera with less than 5Mp, either consider upgrading or using the stitching technique described here.

! What matters most is the use to which the image is going to be put. Commercial reproduction requires much higher resolution than printing on an inkjet.

! If you can't afford a camera with a higher resolution and you still want outdoor shots, concentrate on close-up images showing plenty of detail. The lack of absolute resolution will not be apparent.

6 layers

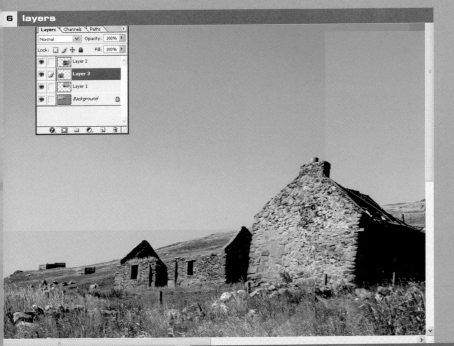

7 levels

the middle is where the maximum distortion will be evident, from the left to right pictures. It may be necessary to use the scale option on one of the layers to make it a better fit.

Next, levels and curves were used on each layer to make them as close to each other as possible. This makes cloning the joins together much easier if you can't easily see them in the first place. The sky on the left hand side matched perfectly after curves adjustment (7).

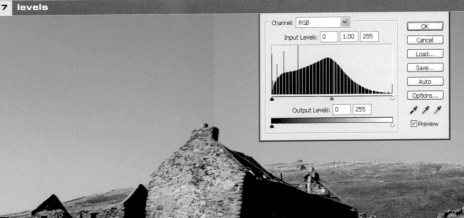

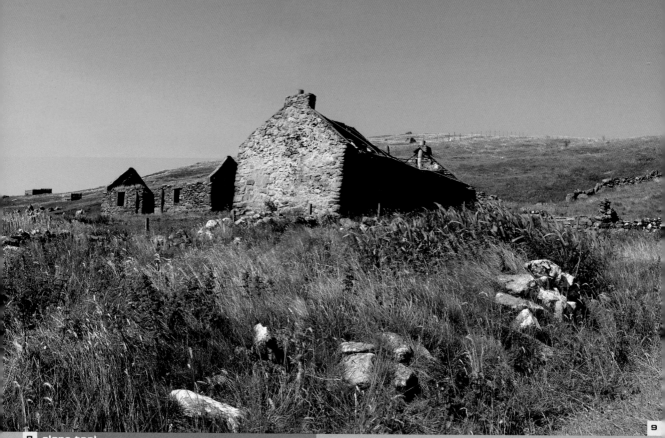

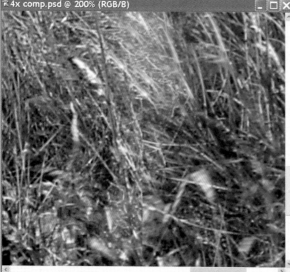

8 clone tool

File Edit Image Layer Select Filter View Window Help

Brush: 34 Mode: Lighten Opacity: 100% Flow: 100% Aligned Use All Layers

4x comp.psd @ 200% (RGB/8)

Next the joins needed to be sealed. This is the hardest part. Use the clone tool at 100% – any less will make the image soft – and apply the lighten blend mode to copy dry flowers, shoots etc. across the image join, while retaining dark undergrowth (8). Use the darken blend mode to move patches of shadow and dark grass across the join. The intention should be to avoid creating duplicated patterns, rather to extend patterns and shapes that suddenly get cut off by the join. You need to clone from each side, depending on what is there. Brickwork is easier to clone and you can use the normal blend mode at 100% to fill out rocks and stones. Simply avoid repeated patterns and obscure the join. Then crop the image to get rid of the spare bits around the edges. Finally, hue/saturation, curves and unsharp mask should be used to spruce up the final image.

8/ The clone tool and lighten blend mode are used to copy grasses and shoots across the image join.

9/ The completed image is exactly the same as the one envisaged through the viewfinder, but it packs three times more detail!

The alternative to stitching pictures is interpolation, which is the science of taking readings from adjacent pixels, averaging them out and inserting a new one between the originals. Photoshop does a good job of this, but there are those who insist that it should not be used to increase an image more than 20% as it leads to an unacceptable softening effect. I say look at how you are going to use the picture before you start drawing boundaries. A portrait shot at 3Mp, blown up in size to 300dpi, A3 will look far more acceptable than a landscape picture which has had the same treatment. The landscape will lose sharpness that will be readily apparent and while some degree of apparent sharpening is possible with the unsharp mask filter, it has its limitations on interpolated images. Also, if you are compositing images, then an out-of-focus background can be blown up to a very large degree, bearing in mind that if the original was a JPEG file then the compression artefacts will

suddenly become very apparent and may need retouching to remove them.

To increase the physical size of an image, go to Image > Image Size in Photoshop and enter a new width and height. The resample image box will need to be ticked. If the constrain proportions box is also ticked then only the width or the height need be changed as the other dimension will change to retain the same proportions.

If the resample image box is not ticked, the width and height dimensions are locked, and all you can change now is the print density. By default this is set to

72dpi as this is the common monitor pixel density. It shows how large the image would be printed at the resolution indicated. By changing this to 300dpi you can see how large the image can be printed using commercial print services. If the resample image box is ticked, you can change the dpi here and the pixel dimensions will change accordingly as the image is resized.

Genuine Fractals is a product by Lizardtech (www.lizardtech.com) that goes one step further than the Photoshop interpolation routines by using fractal mathematics to interpolate images. The image must first be saved in the native Genuine Fractals .STN format, then, upon loading, it can be resized at will for printing. While significant enlargements still produce extra noise and slightly softer pictures, there is little doubt that it offers a high quality, scalable and much more powerful alternative to using the Photoshop routines.

10/ The image's dimensions can easily be increased in Photoshop.

11/ The Genuine Fractals interface at work, allowing here, a 200% increase in file size.

enjoy

The completed image is not a panorama, it is simply a higher resolution version of the picture I would have taken. Instead of having a picture measuring 3024*2016 it now measures 5335*3408, which takes it from being a 6Mp image to an 18Mp picture, all without interpolation (9).

10 image size

11 genuine fractals

! Paper type can impact on printing resolutions required. Matt or art papers don't hold the ink as precisely as glossy, so a lower dpi can be used without jagged edges becoming apparent.

The following table shows the image size in pixels required at **150** and **300dpi for a common range of print sizes.**

Print Size	150dpi	300dpi
6"x4"	900x600	1800x1200
7"x5"	1050x750	2100x1500
8"x6"	1200x900	2400x1800
10"x8"	1500x1200	3000x2400
A4	1754x1240	3508x2480
A3	2480x1754	4960x3508

print sizing

Print density, that is, the amount of ink squeezed into every inch or centimetre of paper, determines whether the final print has jagged edges, looks soft or in fact is perfectly fine. It is measured in terms of dots per inch, or centimetres in some countries. The more dots of image data there are per inch of print, the sharper and more detailed the final print will appear. In terms of digital imaging, the dots per inch are actually pixels per inch that are sent to the printer. If there are significantly too few pixels in the image for the size it is being printed, then jagged edges will be apparent. So, the big question is, how many dots per inch do you need for a good quality print. The answer, surprisingly, is variable. For inkjet printers, 150dpi can be considered a minimum and 300dpi the ideal print resolution. Printing at a higher resolution only makes a difference if the image is pin-sharp and the printer and paper are both capable of resolving the extra detail and sharpness.

perception

Now, it should be pointed out that how close the viewer is to the image also determines how satisfactory the print is. Smaller prints tend to be hand-held and thus closely scrutinised. As such a lower resolution and the corresponding lack of quality will be more apparent. However, small print sizes are rarely used for anything other than snapshots, so expectations of quality are lower. At the large end of the printing scale is the A3 print. This is designed for framing and mounting on a wall and as such will be viewed from further away. As a result the lower printing resolutions are perfectly acceptable. The expectations of the viewer are for a quality print, but generally the image content will satisfy that expectation while any lack of absolute sharpness because of the lower dpi will not be apparent because of the increased viewing distance. Good job really because there are few digital cameras that can pump out 4960x3508 size picture files.

1

Pixel Dimensions: 17.9M

Width: 1876 pixels
Height: 2508 pixels

OK
Reset
Auto...

Document Size:

Width: 6.253 inches
Height: 8.36 inches
Resolution: 300 pixels/inch

☑ Scale Styles
☑ Constrain Proportions
☐ Resample Image: Bicubic

! If your A4-sized image is on the soft side, print it at a smaller size. The increase in dpi and smaller printed area will make it appear sharper.

! The more artistic or grainy the image, the larger it can be printed without the lack of precise quality being apparent.

3

exceptions

A final note on this point is that you can get away with lower printing densities on portraits than you can on landscapes. Portraits have a built-in human response condition so slight shortcomings because of low dpi will be overlooked. In the case of landscapes the viewer is usually looking for detail and sharpness – unless the image is moody and misty – so a lower dpi can be a real problem.

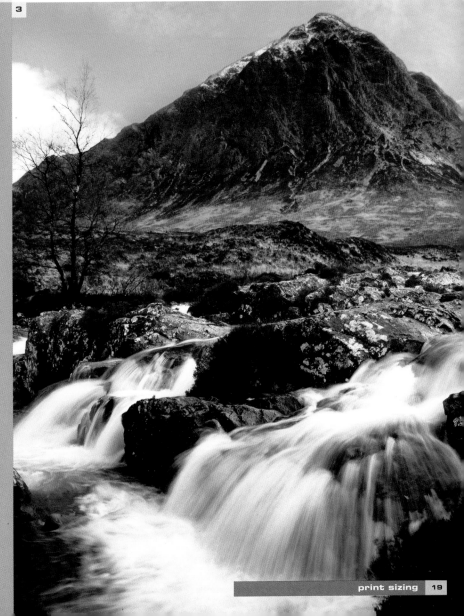

1/ With a resolution of 2636x1844 this image is taller and narrower than the typical A4 page, but there is enough image data to be able to crop it to fit, and as a portrait the loss of a small amount of pixels is not critical.

2/ The image size function in Photoshop should be used prior to saving and printing to set the image dpi.

3/ With a pixel resolution of 2508x1876 this landscape would only make 8"x6" at the commercial reproduction rate of 300dpi. On an inkjet printer at 150dpi it could be printed to fill most of an A3 sheet though the lack of detail would be apparent at this size.

2 electronic output

Gone are the days of washing paper in chemicals in a darkened room, with digital photography the image arrives as a package of numeric data. How you process and use it determine quality and size. Where you need to use or send it impact on how you save and store the digital image. Protecting the digital image is also important when mass electronic distribution is available.

John Andersen lives about five minutes from the spot where this picture was taken (Biscayne Bay in Miami, Florida, USA). He frequently visits this location on the way to work to watch the sunrise. On this particularly calm morning, he was watching this Great Blue heron stalk fish in the flats just offshore. The bird was slightly further away than he would have liked as he only had a 100–400mm telephoto lens. However, the subtle colours of daybreak that the sun and clouds were casting on the water were beautiful, so he framed and shot the image with about a 20% crop in mind.

photographers

John Andersen
Mustafa Soyusatici
Duncan Evans

jdandersen

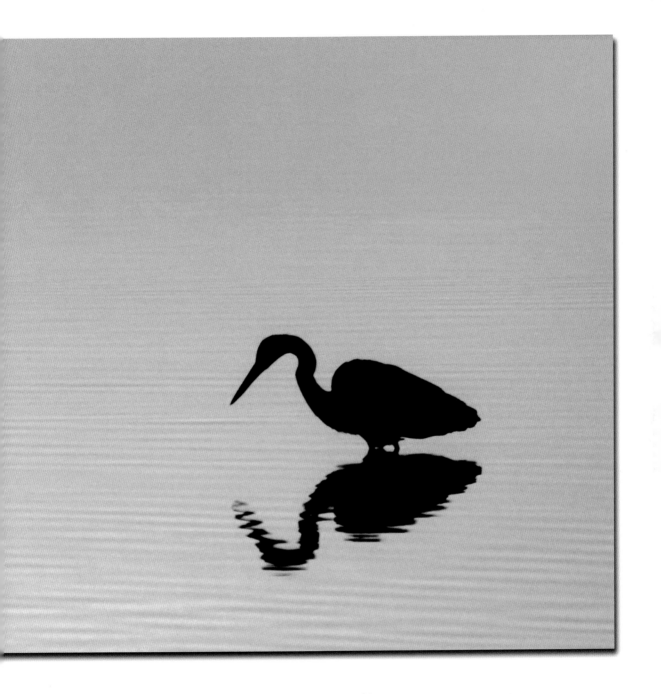

file formats

1

All digital cameras save pictures in the form of image data files, but just as there are different sizes of film stock, there are different file formats and these affect the quality of the image accordingly.

raw

The most unprocessed image format is the RAW file – this is the data that the camera produces without any processing or enhancement. On its own it is not much use, so software has to be used to turn it into a popular file format. Each camera manufacturer uses its own proprietary format for the RAW file for the simple reason that each manufacturer optimises the image differently. Usually software comes with the camera which allows the RAW file to be imported and this then does the basic processing required to turn it into a picture. It may come as a surprise, but most current digital cameras don't sample colour at every pixel or diode on the camera CCD, they sample luminance at all points and colour in the form of an RGB matrix. The camera has a selection of red, green and blue values to work from and uses firmware routines to assess what is in the picture. It then works out what colours to put in the picture. The RAW format uses the basic colour information which is why software supplied by the manufacturer is then required on the computer to work out the final colour balance. As the camera usually does at least a small amount of sharpening and brightness/contrast adjustment as well, you can see that the unprocessed RAW file can look like sludge.

The advantage of shooting RAW files is that they are smaller in terms of storage size than TIFFs, so you can get more on a card. However, the drawback is that they must be processed before being used. The software supplied by the manufacturer to process RAW files is usually a standalone application, though some do provide it as a Photoshop plug-in. The other advantage of having the RAW file is that you can dictate the level of sharpening, colour interpolation, brightness/contrast used to produce the final file format. In digital terms, it's like having an original negative.

jpeg

The Joint Photographic Experts Group 24-bit colour file format is the most commonly used when space considerations start to outweigh quality ones. The JPEG format is a lossy compression system that can be set on the computer by the user, and also to some degree in camera as well.

tiff

The Tagged Image File Format is the most commonly used format when quality is the main consideration. TIFF files are 24-bit colour and can either be saved as uncompressed data – which is what the camera usually does, or with a lossless compression algorithm applied. This means that the file is smaller and suffers no loss of quality, but is still significantly larger than a JPEG, for example. The bigger the files, the more time it will take the camera to write them to a memory card so unless your camera has a large internal memory buffer, you may find it locking up after a few pictures if shooting hi-res TIFFs.

Whereas TIFF files can be compressed up to a 50% file size saving, JPEGs typically compress by 80% before any noticeable quality loss starts to occur. The more compression that is used, the more artefacts produced by the process become evident in the image.

file sizes

Format and compression affect the number of pictures you can store on a memory card in the camera. Judge your quality needs against the space available. This chart will give you an idea of the number of pictures available using file formats, file sizes and quality settings. A Fuji S2 Pro and a 1Gb MicroDrive were used.

file size	format	quality	pictures
6Mp	RAW	HIGH	80
6Mp	TIFF	HIGH	58
6Mp	JPEG	FINE	437
6Mp	JPEG	GOOD	912
3.5Mp	TIFF	HIGH	100
3.5Mp	JPEG	FINE	746
3.5Mp	JPEG	GOOD	1564
1.38Mp	TIFF	HIGH	254
1.38Mp	JPEG	FINE	1493
1.38Mp	JPEG	GOOD	2987

2

gif

Graphic Interchange File. Not an in-camera format, but one primarily used for web graphics. It only uses 256 colours so leads to very small file sizes, ideal for web pages, without the drawback of compression artefacts that heavily compressed JPEGs suffer from.

pdf

Portable Document Format from Adobe. Used for the output of documents containing text and images. Modern magazine and book production now produces PDF files that can be sent on CD to the printer.

bmp

Bitmap. A 24-bit colour format that uses a lossless compression system so is very large and mainly used by Windows system files.

Many digital images never actually get printed, in fact most of them don't but then they don't get used for anything else either. However, there are those images whose purpose and destination is an on-line, virtual existence, for display on the web.

> **RAW format**
> **TIFF**
> **crop tool**
> **drop shadow**
> **border added**
> **colour settings**
> **web graphic default**
> **save for web**

shoot

Mustafa Gündüz Soyusatici of Sydney, Australia shot this photo using a Nikon consumer digital SLR. It was taken at Darling Harbour, Sydney just before a rainstorm. Approaching dark clouds and low angle of the sun over the monorail station resulted in the unusual sky condition.

enhance

The image was converted from the Nikon .NEF RAW format to TIFF and was then cropped and tweaked. Finally a small drop shadow was added along with a thin white border [1].

images for the web

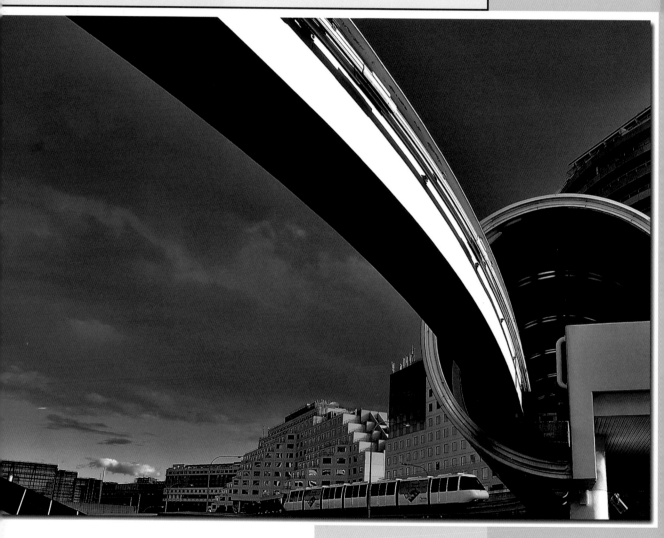

To use an image like this on the web, with a safer colour range for displaying across most systems, go to the colour settings option and choose web graphics default (2).

Use the save for web option to exercise control over which colours are used when saving as a GIF format image with low file size (3).

Use the JPEG option in save for web to both specify compression and to increase smoothing to reduce the appearance of JPEG artefacts (4).

colour

The trouble with putting colour-rich photos online for everyone to see is that you have no control over the monitor the viewer is using. Also most internet browsers don't use embedded profiles so will ignore one if embedded in your image. On top of that, Mac and Windows systems present differing levels of brightness. Actually getting anyone to see your work of art how you want it to be seen is therefore quite hard. There are steps that you can take, however, for making the best of it.

Start by calibrating your monitor (see Chapter 4 – Calibration), then set up Photoshop so that it is configured for producing images for the web. Go to Edit > Colour Settings and either select web graphics default, a custom option that fits your specific needs – this is more likely for banners and graphic artwork rather than photos – or use the sRGB option. sRGB has a much smaller colour gamut than Adobe RGB and is also configured to produce colours typical of a PC monitor. If your photos are already embedded

with another profile then they should be converted. Go to Image > Mode > Convert to Profile and choose sRGB for the profile to use in the destination space box.

For the most significant control over how images will be displayed use the save for web option. Go to File > Save for Web where you can specify which colours are preserved before saving the image in GIF

or PNG-8 format. These are low-file size formats, with reduced colours, that are ideal for web use, but not photos. However, by specifying what are the important colour bands in the photo you can preserve a much better looking image while significantly reducing the file size overhead. Also, for JPEG images, you can embed an ICC colour profile in the image, although only Mac browsers currently support this feature.

1/ The full blown, 24-bit image in all its glory. The challenge with web graphics is to get them as close to the original, despite colour and space limitations.

2/ Choosing the web graphics default in the colour settings options.

3/ Selecting a GIF format to save the image with a low file size for use on the web.

4/ Applying the JPEG option in save for web.

This is a Swedish coastguard ship in Lerwick harbour, Mainland, the Shetland Islands shot on a Fuji consumer digital SLR. A graduated neutral density filter was used to hold back the sky area to balance the exposure and a narrow aperture was used for maximum depth of field.

2 image size

Pixel Dimensions: 1.19M (was 17.0M)

Width: 800 pixels
Height: 520 pixels

Document Size:

Width: 28.22 cm
Height: 18.34 cm
Resolution: 72 pixels/inch

☑ Scale Styles
☑ Constrain Proportions
☑ Resample Image: Bicubic

email and ftp transmission

size

There are many occasions when you need to send images by email, whether to share family photos, send pictures for an advert in the local paper, or to use them in a commercial environment where the image can be assessed for suitability for a particular task. However, it isn't practical to send **17Mb TIFFs** by the bunch, even if you have a broadband or high speed internet connection. For a start, even company mail servers usually have a limit on email size, so that your five lovely pictures totalling 85Mb will probably be rejected by the target mail server, even if your own could cope with sending them.

If you need to send hi-res pictures electronically then they can usually be attached to emails if they come in at under 10Mb. However, if you have lots to send, they may fill up the recipient's mailbox allowance, even if dispatched one by one. If top quality is required and the pictures cannot be saved as JPEGs to reduce the size, then the alternative is to upload them to your website space using an FTP (File Transfer Protocol) program. This avoids any problems with mail servers and allows the pictures to be uploaded at your leisure. All you then need to do is supply the location to the recipient, along with any passwords required to access the site, and they can use an FTP program to download them at the other

1 hue/saturation

Edit: Blues
Hue: 0
Saturation: 57
Lightness: 0

173°/203° 233°\263°

☐ Colorize
☑ Preview

OK
Reset
Load...
Save...

end. If the location is not restricted then Windows users can use an ordinary Explorer window and simply type the address in directly.

Where pictures can be saved as JPEGs, the file size can drop dramatically, while retaining the resolution – see the file formats spread. However, for family photos the resolution is likely to be much smaller anyway, or if it isn't it can be reduced in size for email. A standard size that is perfectly viewable for the

recipient is 1024*768. If you have a lot of pictures to send, 800*600 is nearly as good, though any smaller and the picture loses too much detail to be satisfactory for any real purpose. However, it's at this point that speed of internet access comes into play. When using a fast connection, decent sized JPEG format pictures can be sent at will. With a dial-up modem connection, or sending to a recipient using a modem, smaller sized pictures should be used, bearing in mind that once you get a batch of pictures totalling over 2Mb, it starts to take some time to send and receive them.

Here's a table showing the kinds of time it would take to send various picture file sizes.

image type	resolution	modem	time to send
17Mb TIFF	3024*1965	56.6kbps	50m 4s
17Mb TIFF	3024*1965	512kbps	5m 32s
3.486Mb JPEG	3024*1965	56.6kbps	10m 16s
3.486Mb JPEG	3025*1965	512kbps	1m 8s
763k JPEG	3024*1965	56.6kbps	2m 15s
763k JPEG	3024*1965	512kbps	15s
299k JPEG	800*520	56.6kbps	52s
299k JPEG	800*520	512kbps	5.8s
97k JPEG	800*520	56.6kbps	17s
97k JPEG	800*520	512kbps	1.9s

> digital capture
> levels
> curves
> hue/saturation
> unsharp mask
> **300dpi TIFF**
> resize
> save as **JPEG**

enhance

Levels were adjusted to stretch the tonal range, then curves used to enhance the highlights and shadows. Hue/saturation was adjusted to make the blue sky a little livelier (1), then unsharp mask was used at 50% to make the picture a little sharper.

enjoy

The picture was saved at 300dpi as a TIFF for archive purposes. It was then resized to 800*520 resolution and saved as a JPEG file with a different name for sending by email (2).

1/ Hue/saturation was adjusted to increase the impact of the sky.

2/ After saving the picture as a TIFF, the image was resized and saved again, this time as a JPEG file for sending by email.

3/ The original 17Mb file was reduced to a 97k JPEG file for email transmission.

! When saving a **PDF**, select **PDF** security and click on the settings button to open the security dialogue box. Simply select those options that you need and click on OK.

! Adobe **PDF** reader is freely available, and can be found on many magazine cover **CDs**, or be downloaded from your regional Adobe website.

1 pdf presentation

Source Files
☐ Add Open Files

Browse...
Remove

Save
Cancel

Output Options
Save as: ○ Multi-Page Document ⦿ Presentation
☑ View PDF after Saving

Presentation Options
☑ Advance Every 5 Seconds
☐ Loop after Last Page
Transition: None

output pdf

PDF stands for Portable Document Format and was devised by Adobe. It is most commonly used in magazine and book production, where designs with graphics, pictures and texts can be saved as a **PDF** and sent to the printers. This modern, electronic system is replacing the old way of creating four-colour separated film either in house or at a colour repro house, which would then be sent to the printers. By cutting out a middle step, and for many publishers, a middle man company as well, cost and time savings have been made. But what's this to do with photographs? Well, it's to do with the application of photographs.

security

Converting your pictures to PDF format as they stand has two real benefits for the photographer. The first is that they can be locked in and prevented from being copied or printed. If you are submitting them to a source for evaluation that you don't particularly trust, this can be very useful. For distribution in an insecure environment you can also add a password to the PDF so that only the right people can access it.

Photoshop allows most types of picture files to be saved as PDFs, including RGB, CMYK, greyscale, bitmap, LAB colour and duotone images. Files can have your colour profiles embedded as well. To save a photo as a standalone PDF, simply go to File > Save As and select Photoshop PDF from the format menu. You can specify encryption and security features to prevent unauthorised access to the image. You can also preserve transparency, but not a spot colour channel, which will then show up when the image is opened in another application.

presentation

One of the more general and useful applications of the PDF format from within Photoshop is the ability to save multiple pictures inside a PDF presentation. As most people have a copy of the free Adobe PDF reader, it means the photo presentation can be distributed electronically. Here's how easy it was to create one.

To start, PDF presentation was selected from File > Automate (1). The presentation radio button was clicked along with the option to view the PDF after saving.

The browse button was clicked so that I could select which picture files would be used for the presentation (2). These were added. The options included setting the amount of time each picture was displayed and what type of transition was used to move between pictures.

Security, transparency, colour profile and vector data options can be accessed now, but for this presentation it was a simple case of selecting JPEG at 10/12 quality compression setting for

2 selection

Source Files
☐ Add Open Files

C:\Duncan's photos\photos for LRPS\cd
C:\Duncan's photos\photos for LRPS\cd
C:\Duncan's photos\photos for LRPS\cd
C:\Duncan's photos\photos for LRPS\cd
C:\Duncan's photos\photos for LRPS\cd
C:\Duncan's photos\photos for LRPS\cd
C:\Duncan's photos\photos for LRPS\cd
C:\Duncan's photos\photos for LRPS\cd

Save
Cancel

Browse...
Remove

Output Options
Save as: ○ Multi-Page Document ⦿ Presentation
☑ View PDF after Saving

Presentation Options
☑ Advance Every 5 Seconds
☐ Loop after Last Page
Transition: None

Blinds Horizontal
Blinds Vertical
Box In
Box Out
Dissolve
Glitter Down
Glitter Right
Glitter Right-Down
None
Random Transition
Split Horizontal In
Split Horizontal Out
Split Vertical In
Split Vertical Out
Wipe Down
Wipe Left
Wipe Right
Wipe Up

3 options

Encoding
○ ZIP
⦿ JPEG

Quality: 10 Maximum
small file large file

OK
Cancel

☐ Save Transparency
☐ Image Interpolation
☐ Downgrade Color Profile
☐ PDF Security Security Settings...

☐ Include Vector Data
☐ Embed Fonts
☐ Use Outlines for Text

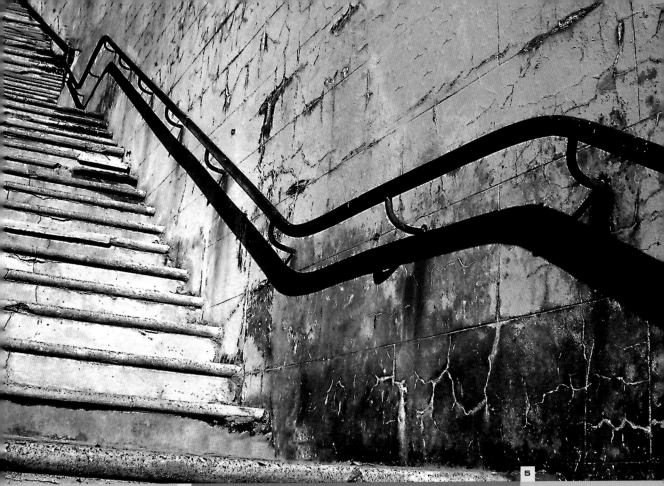

the encoding (3). The ZIP option is lossless, but slower and can only compress at a ratio of 2:1.

And that was it. A 10Mb presentation file was created that, when double clicked on, was automatically played in Adobe PDF Reader. If you have Adobe Acrobat Professional you can import the presentation and add notes or otherwise tweak it (4).

1/ PDF presentation is selected with the option to view the PDF after saving.

2/ The browse button was used in order to select the picture files which would be used in the presentation.

3/ From the options available, JPEG at 10/12 quality compression setting for the encoding was selected.

4/ In Adobe Acrobat Professional you can also add notes to your presentation.

5/ This image of steps was taken in Sydney, Australia by Mustafa Gündüz Soyusatici using a Nikon consumer digital compact camera. Saving it in PDF format would allow it to be sent around the world in a secure, unprintable format.

3 colour modes and profiles

Using the right colour space and profiles is vital to maximising the visual impact of your digital images. Understanding their uses is equally necessary when the digital image is taken off your computer and sent to the internet or the printers. Correct colour space conversion can mean the difference between having your photos seen as they were meant to be, and being flat and lifeless as out-of-gamut colours are clipped.

Alec Ee of Singapore shot this image on his Nikon digital SLR. It was a hot day at Bodie State Historic Park in California, USA. The sand on the ground was overexposed so he cloned in some grass on the right side. He then adjusted the perspective with Adobe CS and used the unsharp mask. Colour was added to the bench before conversion to CMYK for commercial printing here.

photographers

Alec Ee
Duncan Evans
John Braeckmans
Daryl Walter
Nina Andersen

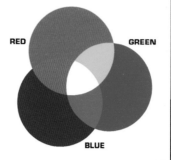

1

rgb

RGB consists of red, green and blue channels and is an additive colour creation process. By this, it means that red, green and blue coloured lights or inks are added together to reproduce a wide range of colours from the visible spectrum. These colours are called primaries, where two overlap they create a secondary colour such as cyan, magenta and yellow. At full intensity, all three channels combine to produce white. This system of colour generation is the predominant one used for monitors and TV, lights and video.

photoshop rgb

In Photoshop's RGB mode there are three channels, one for each colour, with an intensity value of 0 (black) to 255 (white) for each pixel. If all channels have the same values then the resulting pixel is a shade of grey, unless they are all zero, in which case it's black, or they are all 255, in which case the result is white (1).

The three colour channels offer 8-bit colour each, combining to produce a 24-bit colour image with a maximum possible colour combination of 16.7 million. This is also known as true colour. However, RGB images can also be converted to use 16-bit channels, which gives a 48-bit colour image. While RGB is a standardised colour model, the exact colours it uses can vary. What colours are used by Photoshop are determined by the working space, which in turn is defined by the RGB colour profile selected in the colour settings dialogue box. The two most common ones are sRGB, which is used by many digital cameras, and Adobe RGB 1998, which has a wide colour gamut.

As your monitor uses RGB to generate the images on screen, when you switch from RGB – the

default Photoshop colour model – to CMYK for example, Photoshop has to translate the CMYK values to an RGB approximation so that they can be displayed. Fortunately, RGB has a much wider colour gamut than CMYK so this is usually a fairly accurate process. Also, the monitor rendition of RGB varies according to the operating system of the computer you are using. Images appear darker on a Windows system than they do on an Apple Mac because the standard Windows working space is darker. If you are porting images across computer systems you can preview what they will look like by going to the View > Proof Setup and selecting Mac RGB, Windows RGB and Monitor RGB commands.

For digital photographers, captured images are always in

3

2 colour channels

Layers	Channels	▶
👁	RGB	⌘~
👁	Red	⌘1
👁	Green	⌘2
👁	Blue	⌘3

RGB format as the digital camera is an RGB device using a three-colour matrix. While newer cameras have added extra colour detection cells to the CCD matrix, they still remain an RGB device. Images should be edited and completed in RGB before conversion to CMYK if intended for commercial printing processes.

1/ This is the colour model of RGB which shows the relationships between the colours. Red, green and blue are the primary colours, which combine to form secondary magenta, cyan and yellow colours. Unfortunately, the actual colours shown here are much duller than the real RGB colours, as this image has been converted to CMYK for printing in this book.

2/ The colour channel palette – blown up – showing the three components of an RGB image.

3/ This picture was shot on a digital camera – an RGB device – and after editing in Photoshop, saved as an RGB TIFF format picture. The wider range of colours in RGB suits images like this where there is subtle colour graduation, in this case blue, throughout.

colour channels

All Photoshop images have one or more colour channel, the number depending on the colour model being used. Bitmap mode, greyscale, duotone and index colour images all have just one channel, RGB has three colour channels (2), LAB has two colour and one luminance channel and CMYK has four colour channels. As well as the colour channels, an image can have extra ones dedicated to masks and spot colours – these are called alpha channels. Incredibly, an image can have up to 56 channels in total.

! Some Photoshop filters don't work in CMYK mode, so complete all such operations in RGB first.

shoot

John Braeckmans of Lier in Belgium shot this interior picture with a Canon consumer digital SLR and an EF-S 18–55mm lens (1). It's a new place called Colibrand and is used as a café and exhibition location. John was making shots for documentation and a publicity leaflet.

1

cmyk

While virtually all digital imaging devices use **RGB** as a default colour model, thanks to its wide range of colours, commercial printing – books, magazines, posters etc. – uses **CMYK** instead. This stands for the four components, or process inks, that go to make up an image using this model – cyan, magenta, yellow and black, which is the key colour. The biggest difference between **CMYK** and **RGB** is that **CMYK** has a narrower band of colours, particularly bright, neon-like colours. When preparing images that are going to be used in a commercial print process, you should convert to **CMYK** first to check that the colours have not been detrimentally affected, and take appropriate hue/saturation action if they have. However, it has to be said that there are simply some **RGB** colours that cannot be reproduced using a standard **CMYK** profile.

photoshop cmyk

How it works in Photoshop is as follows: Each pixel in the image is assigned a percentage value for each of the process inks. The lighter the colour, the smaller the percentage of process ink colour while the darker the colour, the higher the percentage. Pure white is produced when all four inks have a value of 0%. The fact that the inks use a percentage system isn't particularly important for digital images, but it is very important for things like coloured text on magazine/book/poster covers as it allows specific shades to be requested from the printer.

When working on an image that is destined for CMYK mode, perform all the necessary functions and filter operations on the RGB image first. Only when these are complete should the image be converted to CMYK. You can use the proof set-up commands to preview what the image will look like in CMYK as you go along.

Now do you want the bad news? Although CMYK is a standard colour model the exact range of colours printed can vary because of the actual press it is being printed on. So, that perfect CMYK image on your screen, may be different when printed commercially. It will be a lot closer to the finished print than simply sending off an RGB image and hoping for the best though. The colours represented can vary, depending on the press and printing conditions. To get a more accurate result, you should choose a CMYK colour profile that matches the type of printing process being used. CMYK working spaces are device dependent because they are based on actual combinations of ink and paper at the printers.

out-of-gamut colours

The big problem with CMYK as mentioned, is that the colour gamut is much smaller than that in RGB, though less so when compared to sRGB. A colour that is outside the range of the CMYK profile that you are converting to would be unprintable and therefore is converted to something that is printable. If your image has bright colours, particularly neon ones, it is advisable to identify them before converting to CMYK, because

once converted, large areas of the image can have essentially the same colour value, instead of a range of out-of-gamut ones. By identifying those that are going to be out of gamut, you can alter them to bring them within the CMYK model, retaining the graduations between close shades that would otherwise be lost.

To identify problem areas before conversion to CMYK, look in the info palette. Underneath the

cursor, Photoshop will report the RGB and CMYK colour value. Anything out of gamut for the CMYK profile will have an exclamation mark next to it. If the colour palette is open when an out-of-gamut CMYK colour is selected, a triangle will appear next to the colour picked, and a replacement CMYK colour will be shown in a tiny box underneath.

To see out-of-gamut CMYK colours across an entire RGB

The shot was cropped to isolate the four tables and make it almost symmetrical with a strong perspective. The seats were placed so that they were not correctly aligned under the tables. This, together with the small flower pots, made the connection and feeling that the place was made for and used by people. On the walls there were little hooks to hang pictures on which were cloned out. Contrast, saturation and the USM filter completed the picture in RGB format.

As well as being printed for selling purposes, this image was also requested for this book. To that end it had to be converted to CMYK. Here you can see the colour palette showing that some of the bright red colours are going to be out of gamut in CMYK.

Switching on the gamut warning and specifying a bright green colour showed more clearly where the problem areas were going to be. These were adjusted before converting to CMYK to ensure a graduation of colours rather than a clipped, lump of a single colour.

! It's the bright, neon colours that are the main problem in CMYK. Tweak the image first in RGB or otherwise there will be large swathes of a single colour where the out-of-gamut colours are converted.

! For bright text on magazines and books, a fifth colour can be specified that adds to the palette and creates much brighter and glowing colours.

2 gamut warning

1/ The original image.

2/ The colour palette shows that some of the bright red colours were out of gamut in CMYK.

3/ The final image after conversion to CMYK for reproduction here in this book.

image, go to View > Proof Setup and select Working CMYK. Then go to View > Gamut Warning. Anything out of gamut will change to the warning colour. This warning colour can be specified and it's best to configure it to something that isn't present in the image so that it really stands out. Go to Edit > Preferences > Transparency & Gamut. Under gamut warning click on the colour box and select a colour to be the warning. You can also specify an opacity to this, so that the original colour underneath can be partially apparent.

LAB colour consists of a luminance channel (the L) and two colour channels, A and B. The A channel produces green-to-red colours, while the B channel produces blue-to-yellow colours. The L channel has values ranging from 0 to 100 and sets how bright or dark a colour is. The colour channels offer between −128 and +127 values representing the colours, though the colour palette in Photoshop only offers values between −120 and +120. The numeric values combine to describe all the typical colours that a person with normal vision would see. As such, LAB mode describes how a colour actually looks, not how much ink or strength of colour is needed for a specific device. Because of this, LAB is described as device independent, though it's truer to

lab colour

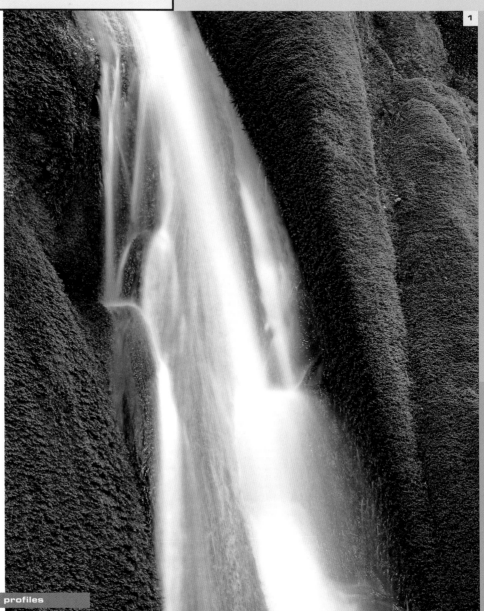

1

While it may sound like something that a scientist might use, the **LAB** colour model is actually a device-independent, colour-rich model. It was designed by the Commission Internationale d'Eclairage (CIE) to be based on human perception of colour. As such, it has a wider colour gamut than either **RGB** or **CMYK** and is designed to be able to print directly to Postscript 2 or 3 devices.

say that it isn't device dependent in the way that CMYK is, as it has such a wide gamut of colours available. LAB is used by many colour management systems, Photoshop included, when converting one colour space to another.

2 lab colour

3 L channel

how it's used

This all makes LAB mode sound like the one to use for general purpose editing of all photographic images in Photoshop, but it isn't. Because it encapsulates such a wide range of colours, if you edited an image in it, when you came to output that image, either to print or to a file format for another electronic system, there is a high probability that colour clipping would occur, resulting in swathes of single colours. You can edit images in LAB mode in Photoshop, but what actually happens is that Photoshop creates a working colour space that is based on your monitor's colour space abilities and a number of the editing options become unavailable.

One of the more trendy concepts of late has been to insist that using LAB mode for creating digital monochrome images gives the best results and more shades compared to any other system. The process simply involves converting to LAB mode, then deleting the A and B channels, leaving a straight luminance channel. Well, sorry to disappoint you, but you end up with exactly the same number of black and white shades – that's 256 – if you do this process, as if you were simply to use the desaturate option or use the channel mixer to convert to monochrome. They all produce a single, luminance channel of 256 colours if using a 24-bit original colour image. It does give a better result than

simply using the desaturate option, but the best method is to use the channel mixer, all of which will be described shortly.

One of the more practical uses for LAB mode is in the PictureCD or PhotoCD format, which is scanned film, rather than an original digital device. Here the pictures can be saved as LAB format TIFFs, giving as wide a colour range as possible, but then this will probably need to be converted when you actually use the image. Unless you have a specific purpose and practical use for a LAB colour model image, it is better to stick to editing in RGB where you can control the colours better and avoid any out-of-gamut problems.

4 A channel

5 B channel

examining channels

Here you can see each of the three channels and what they represent.

Going to the channels palette and clicking on L for lightness shows the luminance of the image [3].

The green-to-red channel shows the values in terms of

brightness – the brighter the data appears in the channel, the more of it and the stronger the colour is in the image [4].

The B channel shows the strength of the yellow-to-blue colours [5].

! If you are printing your own work at small sizes there is no need to convert from your camera's default sRGB colour profile.

! If the images are destined for commercial reproduction they will need to be changed to CMYK files.

colour profiles

As mentioned at the start of the chapter, RGB is the usual colour mode for electronic devices such as cameras and scanners, but within that colour mode it is possible to specify a colour space. A colour space is the range of colours available within the RGB colour mode.

The colour space is defined by a colour profile – digital cameras either use sRGB, or, though not as extensively, Adobe RGB (1998). There is a number of different profiles, each with a specific application or market in mind. The reason why you would want to choose one in particular is that if you are supplying images to a system that uses a very different colour space, the colours in your image would undergo significant change and thus not look how you had imagined them to be.

> digital capture
> convert to Adobe RGB
> enhance colours
> convert to CMYK
> print image

colour space

Most digital cameras use sRGB, while some now allow the choice of Adobe RGB (1998). Your software may be set up to use one particular profile, in which case it will ask if the image should be converted to that working space. You can decline and the software will use the image with the original profile. To set up Photoshop to use a particular space, go to Edit > Colour Settings > Working Spaces > RGB and select a profile. When the advanced mode option is selected in the colour settings dialogue box, all the possible RGB profiles are displayed. The RGB profiles are as follows:

Adobe RGB (1998)
This is the largest recommended RGB working space and suited for print (including magazine/book) production with a broad range of colours. It is the most suitable RGB colour profile to convert to the CMYK colour mode used for commercial print production.

Apple RGB
This reflects the characteristics of the older 13-inch Mac OS monitor. This space is suitable for working with older desktop publishing files or for emulating Photoshop 4.0 and earlier. As such it would not be selected for a modern system.

ColorMatch RGB
Another outdated format, it matches the native colour space of old Radius Pressview monitors. This space has a smaller gamut than Adobe RGB (1998) and was used for print production work.

sRGB
The most common profile used by digital cameras, and also by desktop scanners. It is designed to reflect the characteristics of the average PC monitor so tends to have brighter, simpler colours. sRGB is suitable for web graphics, but conversion to Adobe RGB is recommended for high quality print work. To be honest, if you are just printing out your own photos, it's perfectly acceptable and difficult to tell the difference between the two.

Monitor RGB
This sets the RGB working space to that of your current monitor colour space. The idea is that it is used when further editing in an application that does not use colour management is planned. The image can be converted to the same colour profile as your monitor so that some semblance of visual colour is possible.

ColorSync RGB
Used by the Mac range of computers only, this matches the RGB colour space specified in the Apple ColorSync control panel.

1 colour settings

! If your digital photos are to be used for larger prints, for exhibition, you probably should convert to a wider gamut profile and tweak the photo before printing.

2

shoot

This is a picture of the Skipidock in Lerwick, Mainland, the Shetland Islands, which is a harbour for small boats with a ramp for easy access. The image was shot on a Fuji digital SLR using a 200mm zoom lens.

enhance

The Fuji camera uses an sRGB colour profile. This was converted to Adobe RGB for a wider colour gamut, and then the colours were tweaked and enhanced. The colour mode was then changed to CMYK for commercial printing in this book.

3 **assign profile**

enjoy

The image was printed at 300dpi in this book. It was also used in a feature on the Shetland Islands in a magazine.

1/ The colour settings option in Photoshop can be used to set the profile used as the working space and whether incoming images are converted to that working space or left alone.

2/ Skipidock in Lerwick, Mainland, the Shetland Islands.

3/ Assigning a profile.

1 colour settings

Settings: Custom

☐ Advanced Mode

Working Spaces

RGB: Adobe RGB (1998)
CMYK: Euroscale Coated v2
Gray: Dot Gain 15%
Spot: Dot Gain 15%

Color Management Policies

RGB: Preserve Embedded Profiles
CMYK: Preserve Embedded Profiles
Gray: Preserve Embedded Profiles

Profile Mismatches: ☑ Ask When Opening ☑ Ask When Pasting
Missing Profiles: ☐ Ask When Opening

Description

colour space conversion

One of the little recognised facts of digital imaging is that as the image moves from device to device, or platform to platform, the colours in it invariably change as well. Colour models are used to describe a set of colour values that the image can draw upon. Models such as **RGB, CMYK and LAB** all use different methods of describing colour and also have different colours within those models which are known as spaces. Colour spaces offer even more variations of colour palettes (called a gamut) within the individual models. For example, the **RGB** mode has a variety of colour spaces as described in the previous chapter. While each of these colour spaces describe colour using the same methodology – in this case red, green and blue components – the actual colours used vary from space to space.

original space

Now for the tricky bit. Every imaging device – camera, software, monitor, printer etc. – operates using its own colour space. If you can standardise the colour space and model that all your devices use, then you will minimise the colour shifts that occur as the image moves from one to the other. When using software, the colours are represented by numbers in a digital file but it's important to realise that these numerical values are not representative of absolute colours in themselves. The numbers present a colour on screen because of the parameters of the colour space that defines the colour range.

In digital camera terms, the camera may not offer a choice of colour spaces and in fact it may not say what it uses at all. Most images straight off camera are rarely ideal and require further work, so this isn't a problem in practice. Most cameras however, produce files using the sRGB colour space of the RGB model, which isn't actually the best colour space for photographs. This is down to colour limitations on cameras, rather than for specific intent. Those cameras

conversion intent

When a digital image is converted from one colour space to another – like from sRGB to Adobe RGB – the software uses a rendering intent to determine how this is accomplished. In Photoshop you can specify how this rendering intent works, which is important for you to set up if your camera or scanner produces predominantly sRGB pictures. This determines what the overall appearance of the colours in the converted image will be.

Go to the colour settings dialogue box in Photoshop and click on the advanced mode tick box (2). In the conversion options area you can now choose the rendering intent for colour space conversion. Here are the various conversion options.

Perceptual
This aims to maintain the visual relationship between colours as perceived by the human eye, even though the colour values themselves may change. Not recommended for design or corporate graphics conversion, it is suitable for digital photos where the original features lots of striking colours that are not present in the colour space that the image is being converted to. In practice this is hard to evaluate but if you convert an image using a different rendering intent and the colours look to have shifted then retry using perceptual.

Saturation
This is one for business graphics that use bright saturated colours. It aims to produce vivid colours in the converted image which can be at the expense of absolute colour accuracy. It might be worth trying this on a photographic image if it features lots of bright and gaudy colours, or features things like neon signs.

1/ The colour settings here are configured so that embedded profiles in images are preserved.

2/ By clicking on advanced mode, further options become available in Photoshop that allow the rendering conversion intent to be specified.

3/ A photographic image such as this one would suit being converted from its native profile to Adobe RGB by using the perceptual rendering intent.

that do offer Adobe RGB probably don't offer any more or accurate colours than those that use sRGB, but at least they are using the most useful colour space for photographic printing and one that you should really have your image editing software set up to use.

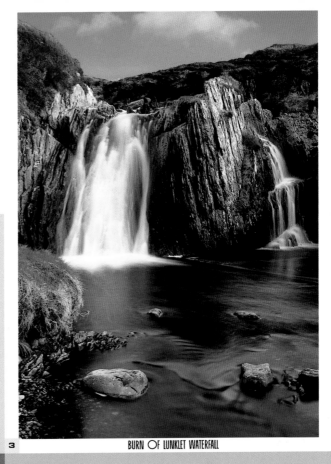

3

BURN OF LUNKLET WATERFALL

2 advanced colour settings

Relative Colorimetric

Worth trying as an alternative to perceptual, the relative colorimetric intent compares the extreme highlight in the source colour space to that in the new colour space and shifts all the colours accordingly. Anything that would not be reproducible is shifted to the closest available colour. This intent preserves more of the original colours than perceptual but it can lead to some colours that are noticeably different. If the image looks like it has a well balanced colour content with no extremes, this intent would be worth trying, but if the result is obvious colour errors then try with perceptual.

Absolute Colorimetric

Not recommended for general photographic conversion, this intent leaves all the colours that are inside the gamut of the new colour space alone. It clips those colours that are outside. This can lead to areas of the image having flat colours instead of variations, though if the scene you are photographing isn't very colourful, they will be reproduced exactly in the new colour space.

The actual purpose of this intent is for colour proofing to simulate the output of a particular device.

! Don't switch your camera into black-and-white mode, even if it has one. Take the shot in colour as you will have more control over the process on the desktop, and also have a colour original as well.

converting to mono

The great thing about digital is that not only do you get a colour photo, you get the chance to turn it into black and white, free of charge. There are a number of ways of doing this in Photoshop, starting with the simple desaturate option. This, however, gives flat images. Another method is to convert an **RGB** image to **LAB** and to delete the AB channels before returning to **RGB**. This gives good results, but is by no means the best method. The one that offers the most flexibility is the channel mixer with the monochrome option box ticked. This allows you to select how much you want from each **RGB** channel to go into a black-and-white version. Using the channel mixer you can tailor the image to give exactly the amount of shadow, mid-tone and highlight detail you want.

> digital capture

> healing brush

> blur

> diffuse glow

> hue/saturation

> soft brush

> JPEG

> convert to CMYK

shoot

Nina Andersen of Oslo, Norway had upgraded to a Canon digital SLR and had just received a new Canon EF 17mm–40mm wide-angle zoom lens. She wanted to get some shots to see how it performed so, as her daughter was playing outside on the deck of their cabin, she went outside and asked her to look into the lens. While posing, her daughter automatically added a wink for good measure.

2 healing brush

3 diffuse glow

enhance

First the patch and healing brush tools were used to remove blemishes from the girl's skin and some dirt she had around her mouth. Then most of the picture was blurred to give a very shallow depth of field. This got rid of some noise and softened the picture, leaving the eyes to give most impact.

After that diffuse glow was added to the picture using a white background colour and settings of – Grain: 0, Glow: 1, Clear: 9. This

! Shooting in RAW mode can be advantageous if the proprietary software supplied with your camera allows the data to be manipulated.

1/ The original capture.

2/ The healing brush was used to remove blemishes from the girl's skin and some dirt from around her mouth.

3/ Diffuse glow was added using a white background colour. It was faded back to 50% using the fade diffuse option.

4/ The second hue/saturation layer mask was used to add colour back into the eye using the soft black brush.

5/ The finished mono result.

5

was then faded back by 50% using the fade diffuse glow option.

Then it was time to get it into black and white. Nina used two hue/saturation adjustment layers to take the colour out in a controlled fashion. Then she painted the eyeball with a soft

black brush (4) on the second hue/saturation layer mask to put the colour back into the eye.

The once colour original image is now a striking monochrome one, but with a subtle dash of colour in the child's eye.

! **Black and white is all about tones and contrast – bear that in mind when shooting digitally in colour.**

enjoy

The image has not been printed at all as yet, but has remained a digital image. It has been reduced in size and saved as a JPEG for display on the internet and also converted to CMYK for printing here.

4 **soft brush**

File Edit Image Layer Select Filter View Window Help

Brush: 343 Mode: Normal Opacity: 29% Flow: 100%

4 calibration

The process of configuring your hardware and software is vitally important to the process of colour management. Even if you cannot afford expensive calibration equipment there are utilities and processes that can be applied that will make your equipment more accurate and your colour output more consistent. Fortunately, most good quality inkjet printers come with custom profiles, saving you the expense, but there are plenty of people who never even integrate them into Photoshop. To put it all together, read on in this chapter.

This is a photo of Dunkeld bridge, in Perth & Kinross, Scotland. It was late one afternoon and golden light was spilling on to the bridge, leaving blue water and a deep blue sky. I used a polariser to remove reflections from the water and an aperture of f22 to generate as much depth of field as possible. Post-production work included a slight crop and a hue/saturation adjustment layer as the AWB of the digital camera had reduced much of the golden colouring.

photographers

Duncan Evans
Jean Schweitzer

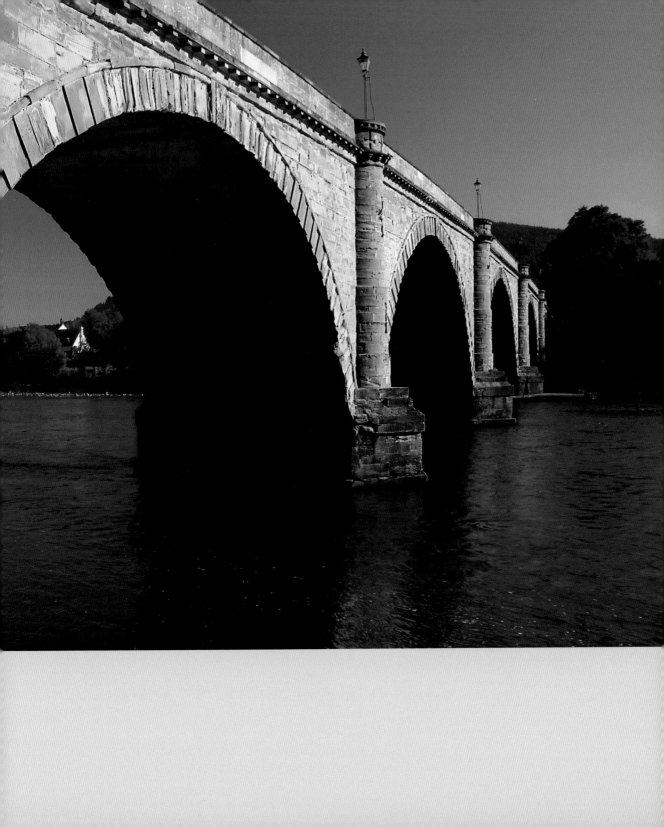

1 adobe gamma

Give the profile a unique descriptive name that will appear in application pop-up menus.

Description: Adobe RGB (1998)

This profile will serve as a starting point for the calibration of your monitor. If you wish to start with a different profile, click on Load.

Load...

< Back Next > Cancel

calibrating your monitor

The place to start when calibrating your system, in an attempt to bring it under some kind of colour control, is with the monitor. Visually comparing what you see on screen, to a printed output is destined for difficulties simply because the screen is a light-emitting device and paper is a reflective one. Even if they have exactly the same colour content, they will look slightly different due to the way the two systems work. When you throw in the fact that the quality of light falling on the print affects how it looks, as does the reflectivity of the surface material, you might be tempted to throw hands in the air and give up. However, it is possible to get things in order and to make colour management as effective as possible, minimising the discrepancies as you move from device to output.

spiders

The most accurate method of profiling your monitor is to use a spider-like device that attaches to the screen and physically reads the light coming through it. However, these are not cheap and it can be hard to justify the expense. A more affordable, but less accurate solution is to use Adobe Gamma. This is a utility that installs along with Adobe Photoshop and can create an ICC (International Colour Consortium) profile that Photoshop, and any other application that uses ICC files, will use for display on your monitor.

Which version of the Windows operating system dictates just where the utility is installed and how it is accessed. For Windows 98/Me go to Start Menu > Programs > Startup Folder or for Windows 2000/XP look in Start > Settings > Control Panel. Start the utility and select the wizard option for a step-by-step guide.

adobe gamma

Confusingly, the first step asks you to give the profile a unique name, while loading a colour space that will serve as a starting point for the calibration. Don't rename it yet – you get that chance at the end – just ensure that Adobe RGB 1998 is the starting colour space. Click on next.

Alter the contrast of your monitor to its highest setting, then adjust the brightness so that the centre of the display box is dark, but not black so that it fades into the border. The border must be kept a bright white as well. This isn't as easy

as it sounds so the best method is to juggle with the white border until you see the point where it starts to go off white. Check the interior box is still visible and if it is, click on next.

If you know what phosphors are used by your monitor you can enter them in the next box, but if you don't then simply use the custom selection and click on next.

For the next setting, you have to move the slider until the central box matches the colour of the exterior box. Don't worry if it doesn't fade into the other

2 adobe gamma

The first step in calibrating your monitor is to adjust the brightness and contrast controls to their optimal settings.

◐ First, set the contrast control to its highest setting.

☼ Then, adjust the brightness control to make the center box as dark as possible (but not black) while keeping the frame a bright white.

< Back Next > Cancel

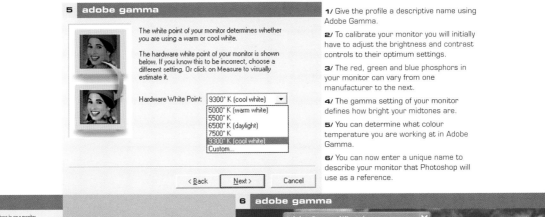

The white point of your monitor determines whether you are using a warm or cool white.

The hardware white point of your monitor is shown below. If you know this to be incorrect, choose a different setting. Or click on Measure to visually estimate it.

Hardware White Point: 9300° K (cool white)

- 5000° K (warm white)
- 5500° K
- 6500° K (daylight)
- 7500° K
- 9300° K (cool white)
- Custom...

< Back Next > Cancel

1/ Give the profile a descriptive name using Adobe Gamma.

2/ To calibrate your monitor you will initially have to adjust the brightness and contrast controls to their optimum settings.

3/ The red, green and blue phosphors in your monitor can vary from one manufacturer to the next.

4/ The gamma setting of your monitor defines how bright your midtones are.

5/ You can determine what colour temperature you are working at in Adobe Gamma.

6/ You can now enter a unique name to describe your monitor that Photoshop will use as a reference.

The red, green and blue phosphors in your monitor can vary from one manufacturer to the next.

Your current monitor profile indicates that your monitor uses the following phosphors. If you know this to be incorrect, please choose a different setting.

Phosphors: Custom...
- EBU/ITU
- HDTV (CCIR 709)
- NTSC (1953)
- P22-EBU
- SMPTE-C (CCIR 601-1)
- Trinitron
- Custom

< Back Next > Cancel

The gamma setting of your monitor defines how bright your midtones are. Establish the current gamma by adjusting the slider until the center box fades into the patterned frame.

☐ View Single Gamma Only

< Back Next > Cancel

setting suits photographs more, if looked at in non-colour profiled applications. What matters is that Adobe Gamma finds out what setting is being used. If your monitor doesn't have these settings, turn off the lights in the room and click on measure to manually calibrate it.

After clicking on next the process is complete. Click on finish and now enter a unique name that describes your monitor so it's immediately obvious to you. This is the setting that Photoshop will now use.

Adobe Gamma Wizard

You have now completed the Adobe Gamma Wizard.

To save your settings, click on Finish.

< Back Finish Cancel

Save As

Save in: color

My Recent Documents
- AdobeRGB1998.icc
- adod6522.icm
- appd6518.icm
- AppleRGB.icc
- BlackWhite.icc
- CIERGB.icc
- CNB5xCA0.ICM
- CNB5xCB0.ICM
- CNB5xDA0.ICM
- CNB5xEA0.ICM
- CNBJPRN2.ICM

- ColorMatchRGB.icc
- Diamond Compatible
- EuroscaleCoated.ic
- EuroscaleUncoated
- FinePixRGB18.ICC
- Hitachi Compatible
- is330.icm
- JapanColor2001Co
- JapanColor2001Un
- JapanStandard.icc
- JapanWebCoated.ic

File name: My avorite AdobeRGB1998.icc Save

Save as type: ICC Profiles Cancel

boxes as the wizard requests. Remove the tick from view single gamma only and try to get all three colour boxes aligned for more accuracy. Click on next when done.

Your monitor will need to be fairly new for the next test as it defines what colour temperature it is working at. Typically, a new monitor will offer a daylight (65000K) or bright, white with a blue tinge (9000K) setting. The higher setting is generally more pleasant to look at for working with Microsoft Office applications, while the daylight

other monitor calibration

Adobe Gamma applies its settings when Windows starts so if you have another monitor calibration utility installed that produces ICC profiles, you should either disable that utility or Adobe Gamma on startup. Otherwise the two utilities will clash producing an incorrect setting. If you have used a hardware device to create a monitor profile, it is recommended that you use Adobe Gamma to actually load and apply that profile to the system. To do this, run Adobe Gamma as

normal, but this time click on the load button next to the description box. Browse to the profile that has been created by your hardware, click on it and click on open. Click on OK. When the message 'save changes to the profile before closing appears?' appears, click on save to do so. After Adobe Gamma is then closed, that hardware created profile will be used by Photoshop, and on the next restart, by the Windows system.

printer and paper scanning

If your printer comes with a purpose-built profile then all good and well, you are well on your way to good colour management. If it doesn't or you need extra accuracy, then profiling the printer and paper becomes necessary. This requires additional hardware, which can vary from quite cheap – simply providing one profile for all purposes – to quite expensive, which will provide profiles for every combination of printer, paper and colour or mono ink that you can throw at it. The purpose of using profiles is that when you are printing, you can specify the right profile for the printer and paper you are using in the print space option box of Photoshop.

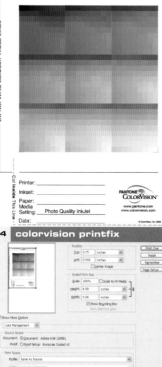

calibration in practice

This is the process used to calibrate an Epson Photo 1290 printer using a Pantone ColorVision PrintFIX patch reader.

The PrintFIX software was started and the Epson 1290 printer type selected along with the paper type being used. Load calibration chart was selected and OK clicked to start the process (2).

The colour calibration chart was loaded (3). Then the matte paper stock was loaded into the printer and print with preview was selected.

In the colour management options the document was set as Adobe RGB 1998 and then the print space profile was set as same as source (4).

Clicking on OK brought up the print dialogue box. The correct printer was selected then the properties box clicked (5).

The paper type was selected along with custom settings for

Once calibrated, a printer and paper profile does not need to be updated until roughly 500 prints have gone through the printer, then it should be redone.

7 colorvision printfix

Custom Settings | Information | Language

○ Black/White ○ Gray ● Color

Resolution(dpi): 400

Scan size: User Defined

Brightness: 0%
Contrast: 0%
Gamma: 2.0
Highlight: 255
Shadow: 0

Width: 4.0 in Height: 4.5 in
Image size: 351 KB
Free disk space: 1857 MB

● Range ○ Zoom +/- Unit Reset Calibrate
Paper sensor=0 Preview Read Cancel

1/ The PrintFIX patch reader and the colour chart printed out from the Epson printer.

2/ To start the process of calibration, select load calibration chart and click OK.

3/ The matte paper stock was loaded into the printer and print with preview was selected.

4/ In colour management, the document was set as Adobe RGB 1998 and then the print space profile was set as same as source.

5/ By clicking OK, the print dialogue box was activated. The correct printer was selected, then the properties box was clicked.

6/ Here the paper type has been selected

together with custom settings for colour.

7/ The PrintFIX application was launched and black/white selected. Settings were left as the default options and then calibrate was clicked on.

8/ The black-and-white calibration chart has been loaded into the reader and the calibrate button clicked.

9/ The process was duplicated using the colour setting and the colour chart.

10/ A test image was loaded and the newly created profile was selected.

colour (6). The advanced box was clicked, the print quality set to maximum and colour management turned off. The colour chart was then printed out.

Now it was time to calibrate the patch reader itself. The PrintFIX application was launched and black/white selected. All the settings were left as the default options and then calibrate was clicked on (7).

If the scanned charts show distortion or smearing then this is the place to clean the patch reader with a fabric cloth and the clean selection. Otherwise the black-and-white calibration chart was loaded into the reader and the calibrate button clicked (8).

Once completed the process was duplicated, this time using the colour setting and the colour chart. Once this was successfully scanned it was time to restart the application and select build profile (9).

This built a profile based on the scanned chart, which could then be saved with a unique name. A supplied test image was loaded and in the print space option, the newly created profile was selected. The test print could then be checked against the file on screen and any minor adjustments to the profile made (10).

8 calibration page

To always get the best results, this dialog box will appear when you press the Calibrate button in the Custom Settings page, or in the situation that you haven't made the calibration before.

Calibrate — Insert the black _white calibration paper provided, and press the Calibrate button.

Clean — Insert the Clean Paper then press the Clean button. Alcohol or similar liquid solution is recommended to be dropped on the Clean Paper if the pollution can not be cleaned out by Clean Paper.

Cancel

! If your printer already comes with a profile and you are using paper stock that was used to create the profile, then there is little advantage in investing in a single profile reader.

9 print reader

Build Profile

! IMPORTANT
For best results, set the Media Type of your Epson printer to Archival Matte or Enhanced Matte.
If these choices are not available, then choose Photo Quality Ink Jet. These Media Settings should be used for all paper types.

Brightnes: 0 Cian: 0 Red: 0
Contras: 0 Magent: 0 Green: 0
Saturatio: 0 Yellow: 0 Blue: 0

PANTONE COLORVISION

© 2002-03 ColorVision Inc, All rights

Cancel OK

10 print reader

PDI Test Image.tif @ 33.3% (RGB...

Print

Position
Top: 1.335 inches
Left: 0.925 inches
☑ Center Image

Scaled Print Size
Scale: 100% ☐ Scale to Fit Media
Height: 8.35 inches
Width: 6.183 inches
☑ Show Bounding Box
☐ Print Selected Area

Print...
Cancel
Done
Page Setup...

☑ Show More Options

Color Management

Source Space:
Document: ● Document: Adobe RGB (1998)
Proof: ○ Proof Setup: Euroscale Coated v2

Print Space:
Profile: epson printer profile
Intent: Saturation
☑ Use Black Point Compensation

1

setting up photoshop

Having read through the chapters on colour modes, profiles and this one on calibration, it should be apparent by now that good colour management is all an exercise in damage limitation. If the end print looks pretty much like the image at the start then you can count that as a result. Put it this way, I've had **18 years** in magazine print journalism and have long since stopped being amazed at how differently front covers end up being printed, compared to what we finalised on screen, or even had on colour proofs from the printers themselves. As well as the vagaries of colour management, the more people involved in a process, the more opportunity there is for human error to foul things up. At least with printing your own images, that possibility is removed, and that's what colour management on your computer is all about – making the process as accurate, error free and consistent as possible.

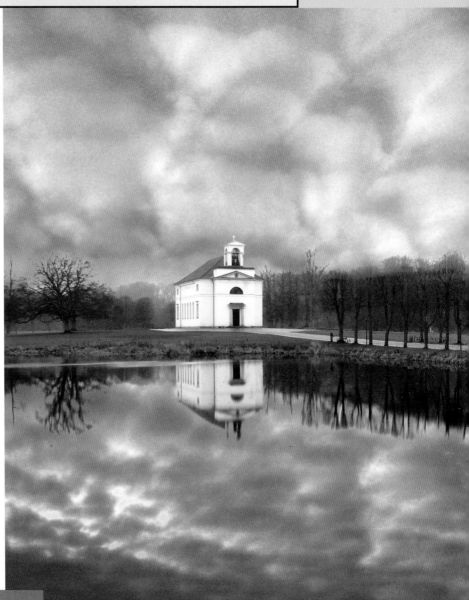

getting control

The first step in colour management is calibrating your monitor, as without this the rest of the system doesn't know what you are looking at. Everyone sees colour slightly differently, some more differently than others, but if the hardware has the same reference point to work from, and uses the same conversion system, time and time again, then you will get consistent results from your equipment.

Once the monitor is calibrated the Windows or Mac system itself will use those settings, as will Photoshop. The next stage is setting up the working spaces (see Chapter 3 – Colour Modes and Profiles) in Photoshop itself. The working space should reflect the type of images and colour gamuts that you are using or for the destination area you are creating or editing for. For most PC users this can be boiled right down to this: if you are shooting and using digital photographs, use Adobe RGB 1998 and convert your images to that space, or if your images are destined for other computer systems and display on the internet, use sRGB with its smaller colour gamut.

The third stage is printer calibration or profiling. If your printer has been supplied with colour profiles then use these. If not, or you need a more accurate reading, then invest in hardware to scan test prints from the printer. This will generate a profile that can then be used. In Photoshop, when you come to print, in the print source document area select the profile for your printer. Use the rendering intent that suits your purposes – see Colour Space Conversion in Chapter 3 for the details.

With Photoshop using the right colour spaces and profiles, the chances of error are much reduced, but even then, some adjustment may be necessary, particularly when printing in black and white which is prone to introducing colour casts thanks to using colour inks to generate a monochrome image. That's when test printing and manual colour tank adjustment comes into play. See Chapter 7 – Colour Inkjet Printing for details on colour management and printer driver adjustments.

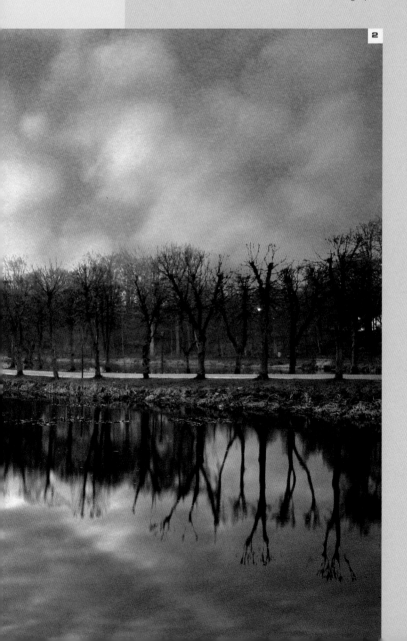

2

5 printers for photography

Just what type of printer is suitable for digital photography, what does it entail and what kind of results can you get? Can I print out on the move, what do I take to a wedding or a dog show that will enable me to sell prints on the day? Those are the questions that people want answering as they look into the various options available in the world of desktop; do-it-yourself printing.

This shot of The Dome of St Peter's Basilica in the Vatican City, Rome, Italy was taken by Trine Sirnes Thorne with a Canon digital SLR and a Sigma EX 180mm lens. She started with the interior of the Basilica, before going up to the top of it, outside. There, with the entire view of Rome at her feet, her husband-to-be proposed.

Trine says: 'I printed this out on a Canon BubbleJet i9950, using A3 Matte Photo Paper. It was mounted beneath glass with a simple black frame. I have taken this picture to exhibitions and sold a number of prints of it, which shows that the quality from the Canon inkjet is of commercial level.'

photographers

Trine Sirnes Thorne
Duncan Evans
Nick Ridley

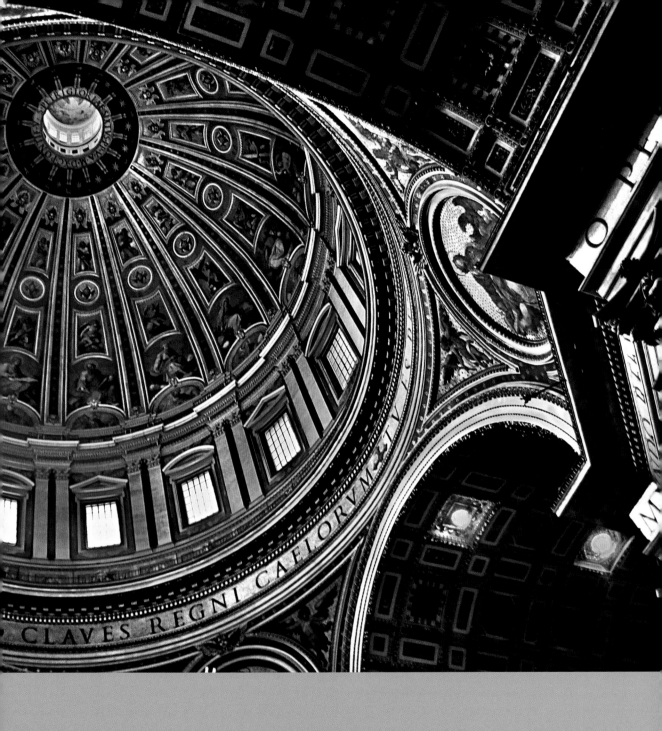

! More ink cartridges mean less ink wastage.

! For photographic purposes, buy a printer that features six inks or more.

! The printer speed should be considered, particularly if you have a lot of printing to do.

inkjets for the home

One of the most common complaints in home printing is that the output doesn't look like the image that spawned it. Is it profiles, calibration or software optimisation that's lacking, the disappointed printer muses? Unfortunately the commonest answer is that these things may have a part to play, however, the overwhelming reason for second-rate output is that the printer itself is simply not up to the job. Far too many people print out photos on printers that feature a colour and a black cartridge, or with a crude, blotchy output, and expect to see photo-realistic results to rival the mediocrity that high street printers produce. Well, sorry but many inkjets aren't capable of producing anything anyone would be proud of, and even more can't produce something that a photographer looking for exhibition quality print would accept.

Currently, at the time of writing, and this has also been the case for the last three years as well, the best printer manufacturers are Epson and Canon. For photographic reproduction that would satisfy a photographer, rather than someone printing family pictures for the album, these are the only two companies producing printers of sufficient quality. Times can of course change, so what should you be looking out for?

For a start, separate ink cartridges for individual colours, with six, seven or even eight cartridges should be looked for. A printer featuring cyan, magenta, yellow, black and then some photo versions of magenta and cyan will usually offer a very good standard of colour repro. For general photographs for home use, even if that does entail putting them on the wall, generally pleasing results can be obtained from four cartridges, but that should be considered the minimum. The very latest printers use up to eight cartridges with added red and green cartridges and can produce the kind of colour seen on slide film.

The other advantage of more ink cartridges is that theoretically they make the printer cheaper to run. With only one colour ink tank, if the magenta component, for example, runs out, the cartridge has to be replaced, even though there is plenty of cyan and yellow left. With separate cartridges, they only need to be replaced when that single colour runs out. However, for running costs to be assessed fully, the total cost of an entire cartridge set change should be weighed against how much ink the printer uses. Generally, the more photographic and better the output, the more ink is going to be used.

1/ The full range of eight ink tanks in the Canon i9950 means that colour reproduction should be the best yet.

2/ The Canon i9950 is the latest example of an eight-ink tank printer, capable of very fast printing speeds at up to A3+ sizes.

Don't get hung up on the claimed dpi resolution of a printer. All home inkjets can produce enough density of ink to avoid jagged edges these days. What is actually important is the size of the ink droplets that the printer produces. Fine droplets mean supreme accuracy and sharpness of detail, while heavier droplets result in the opposite. The Canon i9950, for example, has a 2picolitre droplet size which ensures superfine and microscopic print control. Whether your camera has enough resolution to make use of that is another matter.

One other aspect that should be considered when selecting an inkjet printer is the speed of output. While not the foremost consideration, it is worth thinking about. The recent Canon printer range of A4 and A3 printers has made a name for itself by being at least twice as fast as its closest rivals. When the choice is between waiting nine minutes for an A3 print or three minutes, the time can drag if you have to print out a few pictures at any one time.

2

! In the case of event photographers it is vital to try to get the picture right in-camera the first time, as time spent tweaking is time lost from selling.

! Learn how to use the post-production software so that you can set up batch processing to sharpen, boost contrast etc. before sending to the printer.

! Event photography is competitive, but can be lucrative if you know the shows to attend. Ensure that you have faultless photographic technique so that your pictures sell themselves.

1

event printing

Imagine attending an event as a photographer and not going home afterwards to chase up people some time later who showed interest in getting prints, but now have changed their minds. Imagine actually having a photo-realistic, cost efficient, portable printer on site, churning out photos to interested parties, people who are ready and willing to buy because they are still at the event and want a personal memento to take home. Welcome to the world of event printing.

speed

To print the volumes required, at the speed needed to prevent loss of sales and customer boredom, and at a cost efficient per-print price, you need something other than an inkjet printer. This is where dye-sublimation printers come into their own, working by heat transfer to rolls of glossy paper, and containing both external power leads and a built-in battery for printing from the back of a car in the middle of a field. Dye-sub printers aren't cheap compared to inkjets; they will set you back around £2500–£3000/$3000–$3500. The paper per roll may seem expensive, when it's broken down into the number of prints that come off it, and factoring the cost of the ink cartridge and running costs, the cost per picture comes down to 50p/70c. If you can sell that for £10/$14 then you can see that it won't take many sales to recoup the outlay.

To successfully run an event photography business does take more than just having the right printer of course. You must know your market, be a good photographer, have the right

2 breezebrowser

permissions to set up a stall and be a salesman and computer operator. Commonly, once the photography is done, it takes a two-man team – one to market and sell, and one to operate the laptop and printer – to run the on-site business. There's certainly no time for fancy Photoshop adjustments so other software has to be used to streamline the process, making batch enhancements and running the printer.

shoot

Nick Ridley from Quainton, Buckinghamshire, UK recently went full time as an event photographer, specialising in animal shows and portraits on location. This image was taken with a Canon digital SLR and a 28–135mm IS zoom lens at a dog agility show in Newbury, Berks. [1].

The RAW picture straight out of the camera needed only a little tweaking before printing.

> digital capture
> BreezeBrowser
> Qimage
> interpolation
> dye-sub print

enhance

A number of images were downloaded from the memory card on to the computer and the client viewed them via BreezeBrowser (2). Once the desired picture had been selected for purchase it was sent to the printing software, which was called Qimage (3).

This software interpolated the images to a higher resolution and sharpened the result, without affecting the original file. It then sent it to the printer.

1/ The original capture taken at a dog agility show.

2/ BreezeBrowser was used to enable the client to view the images.

3/ Once an image was selected for purchase, it was sent to the printing software; Qimage in this instance.

4/ The final image.

3 qimage

enjoy

The printer on site at this event was a Mitsubishi CP8000 dye-sub printer which rolled the print out at 9"x6". This was then bagged and supplied to the customer who could take it home and have it mounted. Prints are ready between one and three minutes from sending to the printer, but it is important to realise that there is no fiddling with paper, aligning it and the chance of mis-feeds as it comes off a roll and is cut by the printer. Nick has now upgraded to a Mitsubishi CP3020 which was used to output the image at 10"x8" and back at base it has also been printed, when there were no immediate time constraints, at 19"x13" on a Canon A3 inkjet printer.

The tweaked image rolled out of the printer only one minute after the customer selected it (4). It was bagged and sold there and then.

6 commercial printing

The title of this chapter actually relates to methods of printing that you have to pay for and are not carried out by you. While printing on your own equipment does give you a lot of control, you need to have the right equipment, and there is a lot to be said for getting a high quality print from a photo lab. Also, there are more esoteric options like printing on to objects for use as gifts, or sending wedding snaps to an on-line processor so that other people can access the pictures and order their own copies. Read on to discover the alternative means of getting your work into print.

Cris Benton of Berkley, California spent the summer in Denmark teaching a couple of architecture courses as he is a professor of architecture. He uses kites for low-level aerial photography and took his gear with him on a late afternoon excursion to the village of Gilleleje on the north coast of Zealand. He shot this image by attaching his Canon Ixus/Elph S400 to the kite and flying it over these boats.

Cris says: 'I have made several 8"x10" prints of the Gilleleje rowboats image and think it would go to 11"x14" with no problem. These days I mostly use the Epson 2100/2200P inkjet printer. The image was mounted with an off-white matte and a museum-clip glass frame.'

photographers

Cris Benton
Duncan Evans
Catherine McIntyre

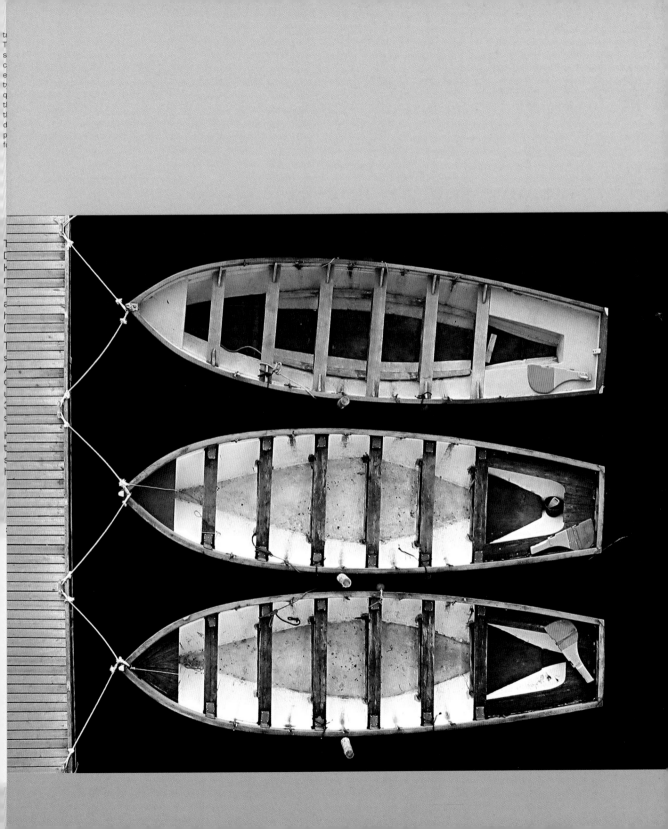

specialist labs

The advantages of using a specialist photo lab to have your digital photographs printed are twofold: firstly the quality is noticeably better than that from a home inkjet printer and secondly you can have pictures printed in larger sizes than would otherwise be feasible.

size and format

The aim, when submitting photographs to a lab, is to give them a picture in the highest resolution possible and uncompressed. Many labs will offer guidelines and limits regarding resolution and how large pictures can be printed. Even though the preferred commercial printing resolution is 300dpi, most labs accept pictures at 200dpi for larger prints, and some will even go as low as 150dpi. When sizing your picture for printing (see Print Sizing in Chapter 1), you should specify the size you want the picture printing at in the Photoshop dialogue boxes, but keep an eye on the resulting effect it has on the printing resolution. If it falls below 200dpi you may need to reconsider the size of your print. Remember, the lower the dpi, the bigger the print, the higher the dpi, the smaller the resulting print.

Most labs will accept pictures on CD/Zip/DVD, but usually specify TIFF or JPEG as file formats. If you are having a digital photo specially printed, it is worth spending time ensuring it is in peak condition, with no JPEG artefacts, or slight blemishes. Save your work as an uncompressed TIFF file, preferably with an embedded colour profile (see Colour Profiles in Chapter 3). Unlike when sending images to a printers, your photo does not have to be converted to CMYK – it can remain as an RGB file, which is a distinct advantage if it has lots of bright colours.

resolution requested

This table is from the guidelines given out by a specialist lab and shows the optimum image resolution for top quality at various print sizes, and the resulting file size. Once the image reaches 15"x12" the dpi required is lowered from 300dpi to 254dpi. At all times, a minimum print density of 200dpi is requested.

Print size (inches)	Optimum image size (at 300dpi then 254dpi)	File size (at 200dpi)	Acceptable image size
6 x 4	1800 x 1200	6.2Mb	1200 x 800
7 x 5	2100 x 1500	9Mb	1400 x 1000
8 x 6	2400 x 1800	12.4Mb	1600 x 1200
10 x 8	3000 x 2400	20.6Mb	2000 x 1600
12 x 8	3600 x 2400	24.8Mb	2400 x 1600
12 x 10	3600 x 3000	30.9Mb	2400 x 2000
15 x 10	4500 x 3000	38.7Mb	3000 x 2000
15 x 12	3810 x 3048	33.3Mb	3000 x 2400
18 x 12	4572 x 3048	39.9Mb	3600 x 2400
20 x 16	5080 x 4064	59.1Mb	4000 x 3200
24 x 16	6096 x 4064	70.9Mb	4800 x 3200
30 x 20	7620 x 5080	110.8Mb	6000 x 4000
40 x 30	10160 x 7620	221.5Mb	8000 x 6000

1/ 2/ Background materials that went into the composition of 'Japanese Winter'.

3/ A blue silk outfit that Catherine McIntyre composited on to the figure.

4/ The original portrait of a student from Japan.

5/ Catherine McIntyre of Kirriemuir in Angus, Scotland, produced this composite picture of a Japanese woman, with textures, cloudscapes and scripts in Photoshop. The final image, called 'Japanese Winter', measured 2953 x 2061 pixels and so could be printed up to 15"x10" at a commercial lab.

unusual print options

If you've shot or created a great image, you will want to make the most of it. Printing out a nice A4 print is all good and well if that's the biggest your printer can do, but there are many more opportunities for maximising the potential of your work, possibly for profit too.

aspect ratios

Most printers will offer some kind of extra service, starting with postcards, business cards, posters and calendars. Others can create large, glossy prints on archival artist's canvas. The most exotic options include making pictures into mouse mats, T-shirts, pens and even as backdrops for snow globes!

There are no real technical requirements for images to be used in these kinds of ways, except ones relating to size and aspect ratio. The pictures from your digital compact are likely to be in 4x3 format, which means that there will be white border stripes on a traditional 6"x4" postcard. However, you can order 8"x6" postcards which fit the compact format perfectly. Digital SLRs tend to shoot in 3x2 format, making them ideal once again for the traditional postcard.

The other aspect of image size is simply that if you are going to have a large print of A3 or bigger, then it needs to be at least 150dpi at that size, otherwise the quality will suffer and it may start to be a case of money down the drain. For smaller objects, the average digital camera can produce image files easily large enough. Even a 3Mp compact can produce a picture good enough

for say a T-shirt, as the process of bonding material to the cotton will invariably lose detail.

If you want to make money from your pictures then postcards and calendars are good avenues to pursue, but you must have

them ready in time for when the shops will accept them. A calendar for example, needs to be printed in spring, for distribution to shops for summer sales, particularly if the area is one with seasonal

1/ There are numerous printers with a website presence advertising their costs and minimum orders for things like postcards.

2/ For a wacky present look no further than websites offering mouse mats, T-shirts or even, believe it or not, your very own snow globe.

3/ If you want to have a more arty effect, a large specialist print using artist materials can be the answer.

tourism. If you get a lot of foreign tourists to your destination then it's worth making your calendar bilingual, as this will improve sales. It goes without saying that if you are producing a portrait-orientated calendar and all your best images are in landscape format, then you've made a rather big mistake. What you need to do, particularly for landscape-based calendars is shoot the scenes the year before so that you have a full range of the seasons, in the orientation that you are going to produce the calendar in. Then pick the best ones to use. Don't simply get to the spring and think about rummaging through your picture library in the hope of finding 12 themed, seasonal pictures in the correct orientation because it won't happen!

4

3 | giclee prints

4/ Catherine McIntyre's 'Muirrúhgach' image is the kind of thing ideally suited to printing as a large size format.

7 colour inkjet printing

The humble inkjet printer is not so very humble these days. Gone are the days of coarse print, splodges of strange ink deposits and unconvincing colours. Instead, thanks largely to Epson and Canon, you can print at home, prints up to A3+ size, in glorious colour, on a wide range of media surfaces other than just matt and gloss. Where once four separate ink tanks were considered cosmopolitan, these days six is the minimum and seven or eight, with bright, photo colours or extra tanks for RGB specific components, are setting the home printing business alight. Whether you do it for yourself, or do it commercially, inkjet printing really has come of age.

This shot was taken by Trine Sirnes Thorne during a spring trip to Rome and Florence. It's one of the many bridges over the river Arno in Florence, Italy. The one barely visible behind it is the more famous Ponte Vecchio. Trine used a Canon digital SLR with Canon EF-S 18–55mm lens.

Trine says: 'I have printed this out on A3+ Canon Photo Paper Pro paper using a Canon BubbleJet i9950. This I glued to a dark cardboard, but it has also been framed with glass and a thin silver frame.'

photographers

Trine Sirnes Thorne
Duncan Evans
John Andersen
Alec Ee

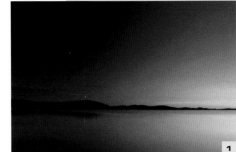

1/ The original photo needed cropping and tweaking, but had a splendid range of colour, if rendered flatly by the camera.

2/ To check what the colours will look like on your printer before printing, go to File > Print with Preview.

3/ You can select the print space area and choose the profile for your printer.

1

colour management

The great advantage of printing your own digital photographs is that you can manage the colour system right through to the final print, instead of relying on a specialist lab or high street outlet.

enjoy

The first thing to do is to calibrate your monitor and create a profile for it. You can use Adobe Gamma if you are a Windows Photoshop user, or Monitor Calibrator if you use a Mac. For a truly accurate calibration you need to use a custom calibration kit (see Chapter 4 – Calibration). If the printer you are using was supplied with a colour profile then ensure that it is installed. If you were given a profile with the printer, or have downloaded one, then it is probably configured for one or more paper types supplied by the manufacturer. If not, then you really need a separate profile for each paper type used in the printer.

The next task is to set up Photoshop to use a colour profile system by going to Edit > Colour Settings. The simplest option is to select Adobe RGB 1998 as the RGB working space, which offers a wide colour gamut that is suitable for digital photographs. If your camera shoots sRGB by default then it is advisable to have it converted to Adobe RGB when you load it. That way, any enhancements you make to the image, particularly colour ones, can be catered for by the colour space you are working in. sRGB has a much smaller colour gamut than Adobe RGB.

Once editing is complete, the photo should be saved using the embedded profile. Before printing you can check what the colours will look like on your printer by going to File > Print with Preview (2). In the print dialogue box click on show more options and select the colour management option from the menu that appears. Look in the source space area and select document so that Photoshop knows what colour space the image has been edited in. Then go to the print space area and select the profile for your printer (3), or a specific profile for the combination of printer and paper if applicable. Photoshop will manage the colour process through printing unless you specifically want the printer driver to handle it. In the print space area select a rendering intent as well (see Colour Space Conversion in Chapter 3). This will

then show you how the colours will be printed using the profiles and hardware at your disposal. The more accurate the profiles, the closer the end results will be to what you are looking at.

Finally, it's time to actually print the photo. Go to File > Print and select the Properties button to access options set by the printer driver. These allow you to set the quality of print and define the paper orientation. There are usually also a number of other functions specific to each printer make that allow enhancements from sharpness to altering how vivid the image is. You can also manipulate the weighting between the separate ink cartridges so that if you know the paper tends to produce a cyan colour cast, you can reduce it here. See the next few chapters for more details on printer driver options. However, if Photoshop is handling colour management during printing, because you have all the profiles required, then you should turn off all printer driver colour options. If you don't have a complete profiled system then you can use the printer driver management system, and through the use of test prints, arrive at tweaked settings within the driver for producing balanced prints. More on this shortly. Note

> digital capture

> hue/saturation

> convert to Adobe RGB

> print with preview

> document colour space

> printer profile

> properties

> print

print properties

that if you are using this method, you should turn off Photoshop colour management of the printing, otherwise the two systems will clash and the colour output may be significantly different from what you both expect and desire.

4/ To access options set by the printer driver, go to File > Print > Properties. This will allow you to set the quality of print and define the paper orientation.

5/ The final image, cropped, edited and then printed out using proper colour management procedures at A3.

shoot

This photo was shot on a Fuji digital SLR with a Sigma 18–50mm wide-angle zoom lens, around 20 minutes after sunset, using an exposure of around 20 seconds. The long exposure has smoothed out the water and recorded the subtle tones of blue in the sky.

enhance

All that was required were some hue/saturation adjustments to bring the colour intensity back up to the level that was present on the day. The Fuji camera uses sRGB which is quite limited, so the image was converted to Adobe RGB.

enjoy

To print the image out the colour management steps outlined opposite were followed. First go to File > Print with Preview (2).

Then, following the instructions opposite, enter the document colour space and the printer profile, plus the rendering intent. Check the colours in the preview (3).

Now go to File > Print > Properties. Set the quality of print and paper type/orientation (4). If happy with the colours and you are using a proper printer profile, disable any printer colour management.

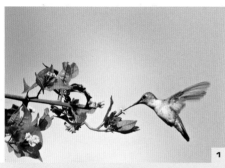

1

! If the print has a cyan, magenta or yellow cast to it, use the printer driver to reduce the amount of that ink being applied.

! If the print is too light or too dark, use the intensity option to balance it out.

printer driver options

If you do not have the software or hardware to calibrate monitors and papers for your printer, the only way to achieve some kind of consistency is trial and error in the use of the printer driver itself. This usually allows not only the paper format and quality setting to be altered, but also the colour balance and more. There may be options for more vivid prints, sharper output, or simply to alter the colour levels from each of the ink tanks. A test print should be made and the ink levels altered until the image is as near the picture on screen as you can make it, then the settings should be saved as a printer option or profile so that it can be used again with the next picture. You'll need different settings for each paper type used.

> digital capture
> Capture One
> Photoshop
> clone tool
> unsharp mask
> add border/signature
> resave as TIFF
> print

shoot

John Andersen of Miami, Florida, USA, used a Canon consumer digital SLR with a Canon 100–400L lens to shoot this image of a humming bird. He had just bought the camera so went to his local zoo to try it out. As he was photographing the flower, the humming bird started to zip in and out, and despite only being able to get a 1/800sec exposure, John managed to freeze it in this position (1).

The original image was shot in RAW mode and had saturation and contrast adjustments before being saved as a TIFF.

enhance

The RAW image was opened in Capture One software and the saturation boosted by about 7%. A slight S curve was applied to enhance the contrast then a 16-bit TIFF format image was saved.

The picture was opened in Photoshop and any dust spots cloned out. Then the unsharp mask filter was applied using settings of Amount: 100%, Radius: 3, Threshold: 0 (2). The border and signature were added then it was resaved as a TIFF again.

enjoy

Go to print, select the correct printer and click on properties to bring the printer driver options up. After checking that the printer is using the correct orientation and paper stock you can select to use various effects (3), if you are confident of the results. This is all dependent on the printer driver, this one being from a Canon i9950. It offers automatic colour correction for casts, noise reduction, monochrome effects and vivid inking.

However, for more accurate control, the manual option should be selected under colour adjustment on the main menu page (4), and then the set button clicked. Some drivers will allow adjustment of each individual tank. This printer has eight ink tanks for example. In this case you can either adjust each CMYK element and the intensity individually, or enable the ICM option. ICM stands for image colour management and is used by Windows 2000/XP to correct colours based on the sRGB profile. If your image is in sRGB mode and the picture has not been modified, this can be a worthwhile option. If the image

2 **unsharp mask**

OK
Reset
☑ Preview

⊟ 100% ⊞

Amount: 100 %
Radius: 3 pixels
Threshold: 0 levels

3 **effects**

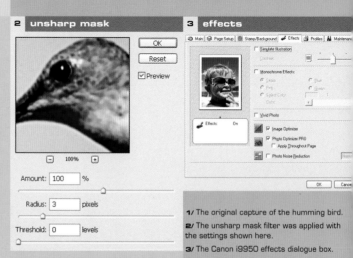

1/ The original capture of the humming bird.
2/ The unsharp mask filter was applied with the settings shown here.
3/ The Canon i9950 effects dialogue box.

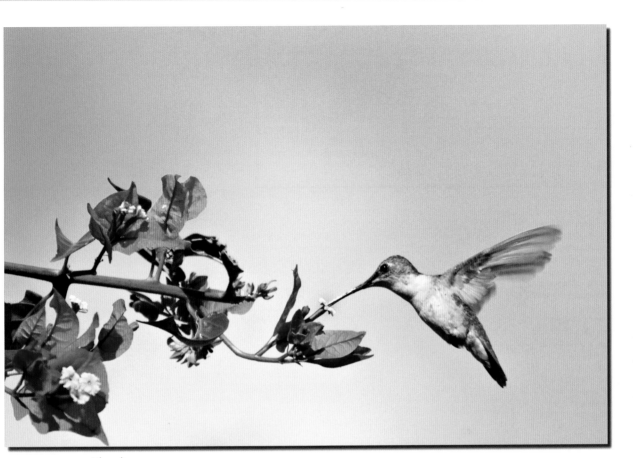

jdandersen

has been corrected and saved as Adobe RGB then it will do more harm than good.

Having made all the adjustments through trial and error to get good, consistent, ink-balanced results you should remember to save the results, or, in this case, click on the option to add to profiles (5), so that you can reuse the exact same settings for this combination of printer paper type and printer.

4 manual colour adjustment

5 profiles

4/ Manual colour adjustments can be made for more accurate colour control.

5/ Once all adjustments to colour have been made you can click on the option to add to profiles so that you reuse the exact same settings again.

6/ The completed image with border, has been printed out for display.

PictBridge

exif and pictbridge

EXIF is an acronym for Exchangeable Image File Format and is a standard for storing information in image files particularly those using JPEG compression.

exif data

Most digital cameras now support the use of EXIF data and embed it in both JPEG and TIFF files. EXIF data for digital cameras includes a mass of information from lens aperture, focal length, use of flash, metering mode and ISO to file compression and picture mode details. If an image is altered, even if that is nothing more than rotating, then the EXIF data can be lost, depending on the application.

EXIF Print is the printing application of EXIF 2.2, which itself was designed for helping print images. EXIF Print carries the information set by the camera, but has been optimised to take advantage of things like scene modes in cameras. Printers sporting the EXIF Print logo can read that data and optimise the print accordingly.

pictbridge

Designed more for use without a PC at all, PictBridge was created by CIPA (Camera and Imaging Products Association of Japan) to make printing digital photos easier. PictBridge allows you to connect a digital camera directly to a printer without a PC, enabling direct printing on the spot, regardless of the make of either. A large number of manufacturers have already announced their commitment to the standard so that for example, of a recent clutch of 8Mp high-end compact cameras by Canon, Olympus and Nikon, all three supported PictBridge, while only two supported EXIF Print. It is also being considered for other applications in addition to printing from digital cameras. To use a PictBridge-supported camera, you simply connect it to a compatible printer – they can be of different makes – via a USB cable and switch the camera on. The camera then controls the print process using the LCD monitor to offer multiple printing, trimming, print size and so on. When you are ready to print, the camera controls the process directly and sends the pictures to the printer, all without recourse to a computer.

2 exif data

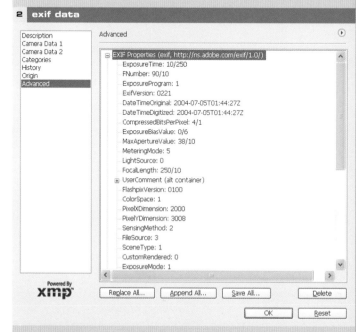

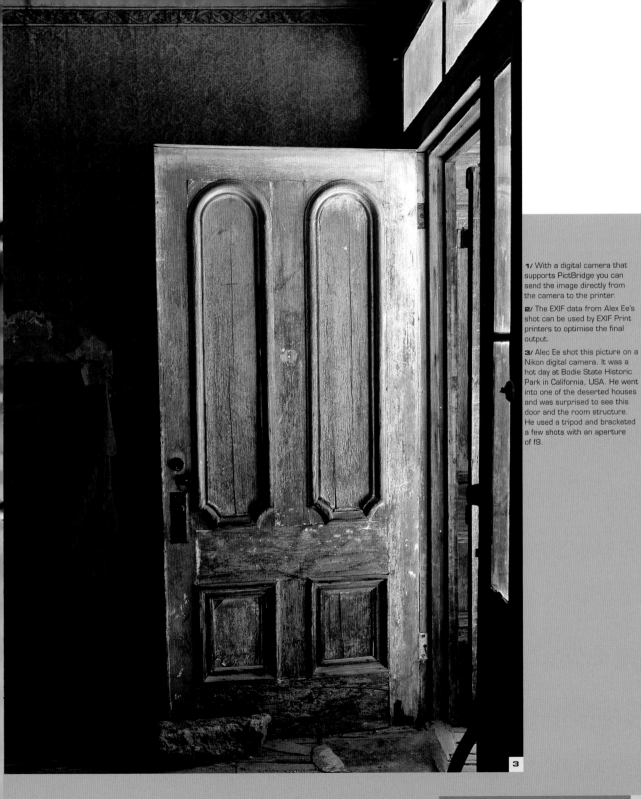

1/ With a digital camera that supports PictBridge you can send the image directly from the camera to the printer.

2/ The EXIF data from Alex Ee's shot can be used by EXIF Print printers to optimise the final output.

3/ Alec Ee shot this picture on a Nikon digital camera. It was a hot day at Bodie State Historic Park in California, USA. He went into one of the deserted houses and was surprised to see this door and the room structure. He used a tripod and bracketed a few shots with an aperture of f9.

3

8 mono inkjet printing

One of the great challenges when printing at home is to get top quality black-and-white results. The tonal range of black and white is everything and this is where inkjets can struggle. Fortunately there are solutions, both in terms of maximising the capabilities of the hardware and inkset that you have, and of replacement ink cartridges that replicate the tonal range of traditional chemical monochrome printing.

Ceri Jones took this shot on a weekend visit to Venice with his wife to celebrate their wedding anniversary. It rained and snowed all weekend, so all images were flat and lacked colour. He had no filters with him, but the vertical sticks, bobbing gondolas and the building in the background provided a nice composition. The water lapping over the pavement also emphasised the wet conditions. The featureless sky was a problem so he replaced it with a more suitable one he had in his collection. Ceri then converted it to black and white and increased the contrast. There were then some selective contrast adjustments to highlight the white building in the background, in order to draw the eye into the picture.

Ceri says: 'If you need to increase the size of the image without significant loss of quality, adjust image size in 10% or less steps. Also, always keep your original shots, I often go back to an image that at first showed no promise and see what can be done.'

photographers

Ceri Jones
Daryl Walter
Duncan Evans
Tiago Estima

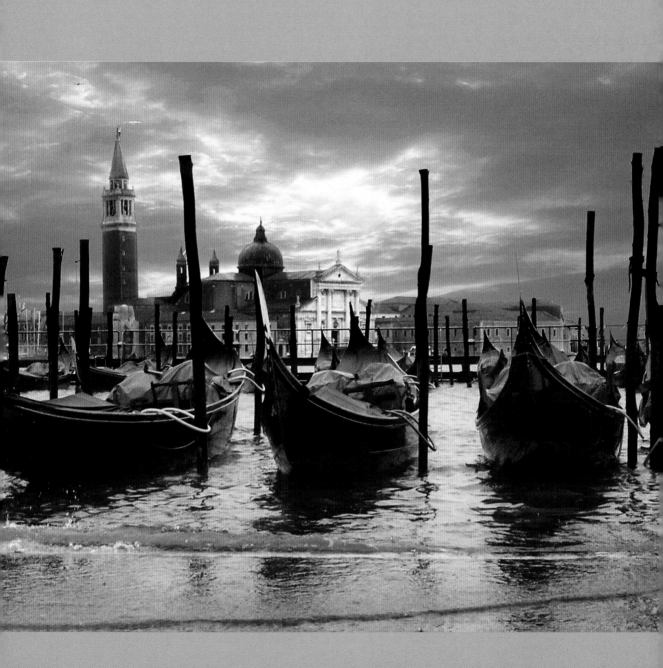

1/ The original colour image of a windmill in Suffolk is pleasant in itself, but it's better in black in white.

2/ The channel mixer was used to convert the image to black and white.

3/ The next step was to adjust the levels and boost contrast.

4/ In print properties you can choose between printing an image in colour or as a greyscale image.

5/ You can select manual colour adjustment and use the sliders to reduce the ink that might be causing a colour cast.

6/ This splendid windmill really stands out in black and white with the tones of the building contrasting with the darkness of the sky.

printing in mono

Having gone to the effort of calibrating your monitor, profiling your print-outs and setting up Photoshop to use the right colour space and so on, it can still come as a great disappointment to send a monochrome picture to the printer and be rewarded with a muddy print with a grim cyan colour cast. Was it all for nothing? Well no, it wasn't, but you do need to take an extra step, and that is to produce a profile for your monochrome prints as well as the colour ones, and use that for your black-and-white work. If you haven't got profiling equipment, it is possible to buy ICC profiles for specific printer/paper combinations and this can be a good time and money saver. Alternatively, if you can't find the combo you want then it's time to turn to trial and error and the use of printer driver options.

> digital capture
> channel mixer
> convert to b&w
> levels adjusted
> AbsoluteDeNoiser
> unsharp mask
> border added
> A3 inkjet print

shoot

This picture was taken in Thorpeness on the Suffolk Coast, UK over an Easter weekend by Daryl Walter using a Canon compact digital camera. It was a bright, sunny day and this white windmill was an obvious candidate for a contrasty, black-and-white image. The camera was hand-held.

enhance

The original image was converted to black and white using the channel mixer (2). The red, green and blue channels were tweaked to make the sky a little darker than in the original shot.

The levels were adjusted and the contrast was boosted (3). Following these changes, noise was removed using AbsoluteDeNoiser (a free java-based noise processor). The final step was a bit of sharpening using unsharp mask and adding a border.

2 channel mixer

3 levels

enjoy

Daryl has printed this image out on a professional Fuji printer, but for the purposes of this book, it was also printed out on a Canon A3 inkjet printer. Going to print then properties you have the choice between proceeding in colour or clicking on greyscale printing (4). Using coloured inks produces a fine print, but runs a much higher risk of a colour cast. Clicking on greyscale means that only the black tank will be used, but this means that the print quality will be much coarser. If the dpi was high, then this shouldn't be a problem, but if you were printing at 150dpi to start with, the deficiencies will be apparent.

4 canon i9950 properties

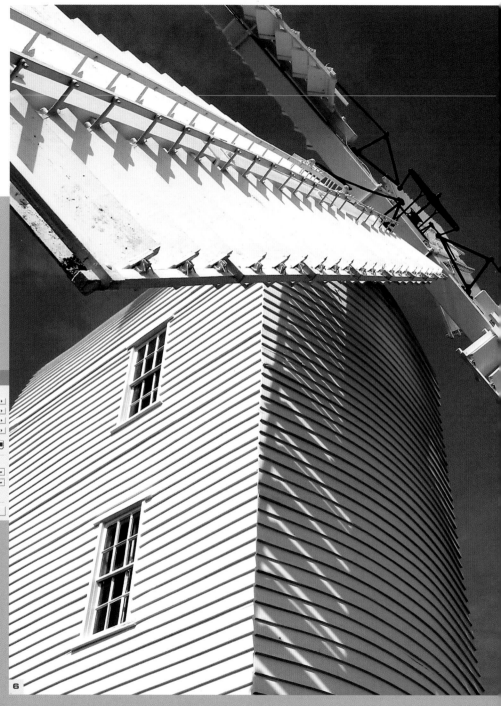

If you do use a colour inkset to print with and there is a cast, select manual colour adjustment and use the sliders to reduce the ink that's causing the cast 5). If the prints are too light, increase the black component, or conversely, if too dark, reduce it.

5 colour adjustments

Color Balance

Cyan:	-7
Magenta:	0
Yellow:	0
Black:	5

Intensity: 0

☐ Enable ICM

Print Type: Photo
Brightness: Normal

OK Cancel Defaults Help

The alternative is to click on greyscale printing and use the manual adjustment to alter the intensity. If you are still getting a colour cast, this is because of the reaction of the black ink to the paper stock. Either try a different paper stock, or print in colour and adjust the colour inks manually to remove it.

6

This is a photo of the Cuillin mountains, taken from Elgol across the water, on the Isle of Skye, Inner Hebrides, Scotland. It was a tempestuous day, with very little colour in the landscape, sea or sky, so well suited to black and white. This was shot on an Olympus digital SLR using ISO 320 as my tripod was back in the hotel at the time.

printer driver options

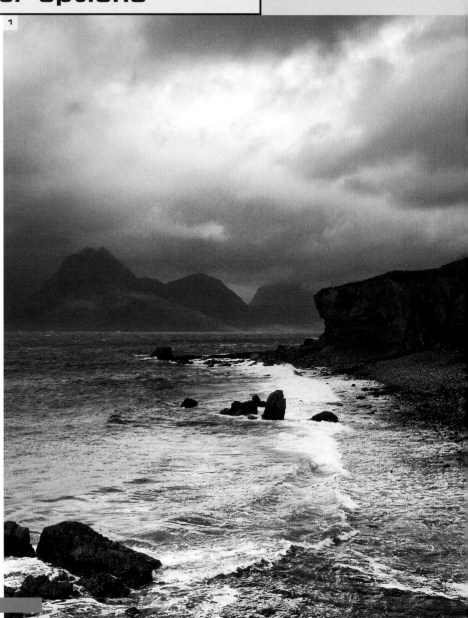

1

Unless you have replaced your standard set of inks with a custom black inkset then there is a simple choice when it comes to printing in mono: use all the colour inks and risk a colour cast or just use the black tank and have a coarser image. Actually, you can even get colour casts when just using the black tank because the paper coating may react with the ink and produce one. This won't usually happen when using the manufacturers own paper media, but if you decide to experiment it can do.

In terms of the changes you can implement to the image at the printing stage it is better to consider them as tweaks when all else has been tried. It is better to have a colour managed workflow, use paper and inks where you can predict the outcome, and simply print the image without recourse to options in the printer driver. However, that's the theory, in the real world things are rarely straightforward. Different papers react differently to ink types. An image may print out perfectly fine on a matt paper stock but be too light on a gloss stock. Without having to change the original image, here's where you can tweak it.

> digital capture

> levels

> feathering

> curves

> print

enhance

Firstly the levels were increased to spread the tonal range out and then areas in the midtone region – the mountains, water and shore – were selected and feathered at 100 pixels. An 'S' shaped curve was applied to make the scene more dramatic (2).

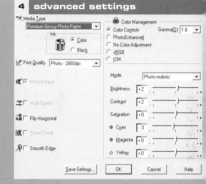

2 curves

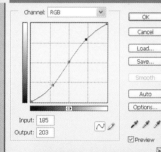

enjoy

Now to the printing. The first option to any mono image is to try printing it using all the inks and with no colour adjustment (3) – leave colour management to Photoshop. If it comes out without any colour casts then not only are your inks being distributed properly, but they are also compatible with the paper you are using.

If the image doesn't match up to what you want then go back into the advanced colour options and adjust brightness and contrast as required, and most importantly, the three main ink colours (4). If there is a cyan cast to the print, reduce the cyan content and so on.

If the problem of colour casts is insurmountable the next thing to try is to use just the black ink tank. Select that in the advanced colour print properties and then you can choose to tinker with the contrast or brightness. The gamma setting alters both at once (5).

1/ The tweaked image has better contrast and tonal range. Converting to CMYK for printing retains all the tones.

2/ An 'S' shaped curve was applied to create a more dramatic scene.

3/ Try printing the mono image initially with no colour adjustments and using all the inks available.

4/ Use the advanced colour options to adjust brightness and contrast if required. The three main ink colours can be tweaked too in case of colour casts.

5/ If colour casts cannot be removed, use just the black ink tank and adjust contrast and brightness in the advanced colour print properties.

! If you are going to be experimenting with printing, set the printer to a lower printing dpi to save time and ink.

! Always keep the original safe and experiment on versions with different file names. There's nothing worse than finding out something doesn't work but you've overwritten the original file.

! This technique applies to all images that are either black and white or have black and a single colour. The more neutral the colour is, the more prominent a colour cast will appear.

1

colour cast solutions

Whether you are printing in mono using all the inks, or with a one-colour tone such as in duotoning, the fact that you are using all the ink tanks runs the risk of a colour cast being produced. Sometimes this is down to the combination of ink and paper, other times it's a lack of accuracy from the printer in mixing the inks, but whatever the cause, it can be frustrating. If you have tried all the other options of calibration and colour management, and still have trouble, there is a final resort to try to get your cast-free prints. It does require a little experimentation however.

shoot

This windmill in Malveira, Portugal was shot by Tiago Estima of Lisbon using a Canon digital SLR and a Canon 28-105mm zoom lens.

2 convert to mono

enhance

The image was converted to monochrome using the channel mixer (2), with the red channel enhanced and the blue channel reduced. The image was

1/ The original image of the windmill in colour.

2/ The image was converted to mono using the channel mixer, with the red channel enhanced and the blue channel reduced.

3/ The gaussian blur filter was applied to soften the picture once it had been colourised to give it a sepia tone.

4/ In variations many effects can be created

5/ If after the first print there is still a colour cast present you will need a stronger effect.

4 variations

3 gaussian blur

colourised to give it that sepia tone. The gaussian blur filter was then used to soften the picture (3).

> digital capture
> channel mixer
> sepia tone
> gaussian blur
> print

enjoy

Now, suppose we were printing this and we got a colour cast. Here's what to do. Firstly create a duplicate layer. Then, go to variations and look around the circle of effects (4). If you can see the colour of the cast that is being produced, look across to the opposite side. That is the colour that should cancel out the cast. Click on it and click on OK.

6/ Reduce the opacity of the corrective colour in the layers palette.

7/ The finished image with a sepia tone and hopefully, no problems in printing.

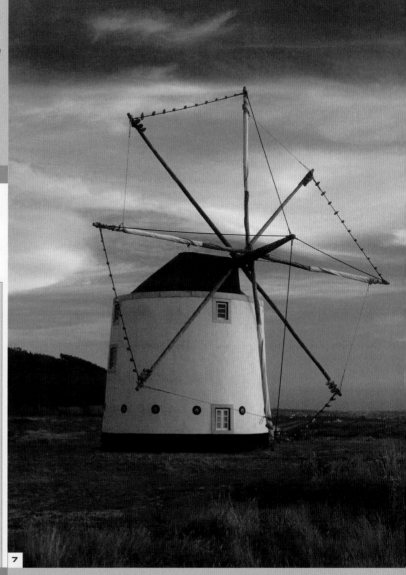

5 variations

6 layers opacity

7

Now print the image and check the colour cast. If the original cast is still there, you need a stronger effect. Go back to variations again (5). Don't reselect the opposite colour this time because Photoshop remembers the last setting. Just click on OK again and print it again.

Now, if the original colour cast has been removed, but you now have a tint the shade of the corrective colour, go to the layers palette and reduce the opacity of the corrected layer (6). Print and check again.

9 alternative ink systems

One of the advantages of the chemical process in printing photographic images is that there is a number of different processes that can be tried to give wildly differing results. In the digital world with inkjet printers, the situation for a long time was simply one of getting good enough quality, but that has been achieved. Now the situation is one of ever expanding choice with different types of inks, continuous ink flow systems and specialist black-and-white inks. Digital photography no longer ends with clicking the save button in Photoshop, now you can carry on into the printing side to give your digital photographs an ambience that would have been impossible just a couple of years ago.

Dirck DuFlon took this picture with a Minolta compact digital camera with a built-in 28–210mm zoom lens. It was shot at the Bok Tower Gardens in Lake Wales, Florida, USA. Dirck and a friend had gone to the botanical gardens there on a photo outing, and he spotted this row of manicured orange trees in the gardens around the Pinewood mansion, built by the original owners of the gardens. He used a tripod and a Hoya R-72 infrared filter and shot using the camera's black-and-white mode.

Dirck says: 'I have made prints of this image in 8"x10" and 11"x14" sizes on my Epson Stylus Photo 2200 printer. This is a seven-colour inkjet system that uses Ultrachrome pigment-based inks.'

photographers

Dirck DuFlon
Duncan Evans
Trine Sirnes Thorne

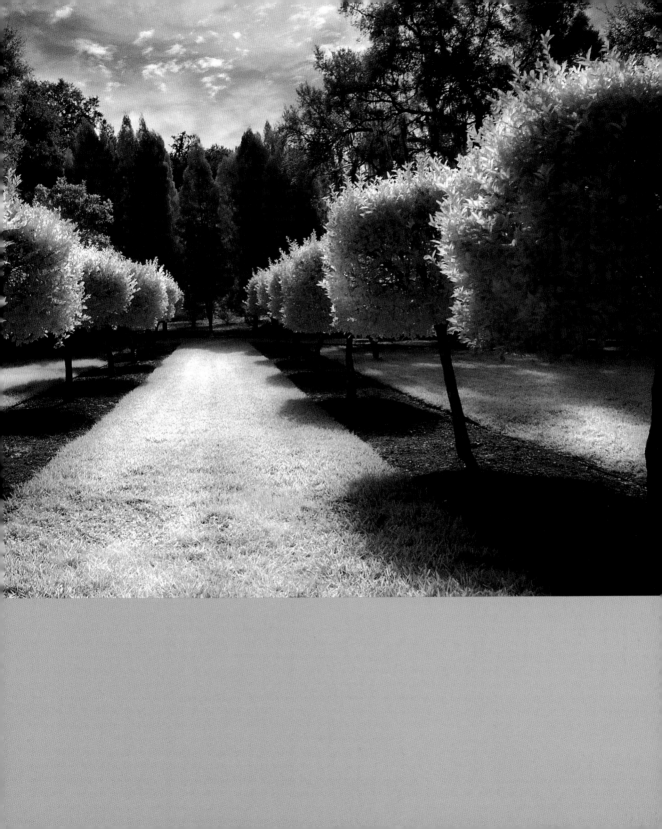

! Don't get into the habit of switching from standard colour ink cartridges to a monochrome set as any spillage or slight bleed from the inks will affect either the new set or the print being made. It's better, if more expensive, to have two dedicated printers.

1

alternative blacks

As explained in earlier chapters, the problem with using your standard inks for printing in monochrome is that the system uses all four ink colours to create a pure black, and colour casts can result. If only the black ink cartridge is used, resolution of print is lost as well as tonal graduation, resulting in coarser pictures. One alternative is to replace the current inkset entirely with custom monochrome inks. It can mean, depending on the system, that you need two printers – one for colour use and one for monochrome printing. If you do switch to a dedicated monochrome inkset it is worth either investing in one that comes with a profile or calibrating it yourself, so as to introduce the highest degree of accuracy when you are paying the extra expense.

quad blacks

One of the most popular alternative black inksets for Epson and Canon printers comes from Lyson in the form of the Lysonic Quad Black. This uses four intensities of black ink in place of the usual cyan, magenta, yellow and black inks to give extra fine black tonal graduation and a print resolution that shows off all the detail in the photo. There are three types of Quad Black inks – a neutral version and ones with a cool blue or a warm red tone.

Lyson's own testing claims that prints made with Quad Black inks exceed the display life of most traditional silver halide images.

Quad Black inks can also be used with a wide range of surface type paper media, from matt and gloss to fine art finishes. The advantages of using Lyson's own papers – and this applies to any ink manufacturer who also produces its own paper, not just put their name on OEM stock – is that there is greater compatibility for adherence to the print and fade resistance. Lyson's papers are specially coated to enhance colours and resist fading. The second advantage with Lyson is that the company provides profiles for specific combinations of its inks and papers using Epson and Canon printers. This certainly increases print accuracy as discussed in Chapter 4 – Calibration.

2

small gamut inks

One of the methods to subtly enhance a black-and-white image is to give it a single colour tint. In the film lab this is a time-honoured tradition involving careful use of chemicals to create the right effect. Digitally there are two options. One is to tone the image in Photoshop and print it out using the colour inks in the printer. The other is to leave the image as monochrome, but use what is termed a small gamut ink cartridge to add a precise tint, while leaving the rest of the ink available to give the tonal range that black and white demands. By using a small gamut inkset the problems of using colour cartridges – greenish midtones, poor greyscale definition, florid highlights and poor shadow detail – can all be avoided. Another advantage of this inkset for the more artistically inclined photographer/printer is that traditional chemical effects such as selenium silver, black and warm duotoning, warm and cool toning and split tones are available.

1/ An alternative printing option for those looking for pure monochrome results.

2/ The range of Lyson alternative colour and monochrome inks and specialist papers.

3

1/ The range of dye inks available from Epson for its range of inkjet printers.

2/ Alternative, archival dye inks from Lyson, promising light fastness and much greater resistance to fading.

1

colour inks

For the newcomer to digital inkjet printing, the questions foremost are either, what's the best quality, or what's the cheapest? However, if you are making prints that you either want to sell or to last more than six months once they've been put up on the wall, then the considerations of longevity and fading start to arise. Standard inks use dyes, which are bright and colourful, but they also tend to fade, particularly if exposed to sunlight or the elements.

inks

Archival dye inks are stronger than ordinary dye inks, except when used on coated papers. UK firm Lyson developed the first generation of archival dye inks which improved the ability to withstand fading. Unfortunately the early inks in this range had poor colour. While colour has since been improved significantly in the Fotonic range, it has come at a cost of fadeability. Archival dye inks will last longer on matt or textured papers, but printing on glossy surfaces chemically affects their ability to withstand fading making them little better than standard, cheaper inks under significant environmental conditions.

The next category of ink is pigmented inks, which attempt to blend the very light-resistant pigment inks with the brightness and colours of regular dyes. These inks can be printed on all but the glossiest surfaces where they can have the tendency to produce mottled effects. This is caused by the uneven absorption of the dye and pigment components. Another problem is that different parts of the print can look shinier than others thanks to uneven absorption and

the difference between the reflectivity of the pigment elements and the dye elements.

The latest development in ink technology is the pigment ink, rather than pigmented, which is made from 100% pigments and little to no dye elements. The advantage is that pigment inks have greater fade resistance than other inks and are not affected adversely by inkjet coatings. Pigment inks which have zero dye components offer the most stability of all. Dye is largely unnecessary to create the traditional colour brightness because an extremely fine spray of microscopic pigment particles allows a very large amount of colourant to be used. There is no mottling effect and the best fade-resistance and brightness of colour combination. Papers which promised to offer brighter, more colourful images have no effect when used with pigment inks, and if there is one paper type that pigment inks may have problems with, it is the very glossy ones. Semi-gloss or satin tends to be the best surface for that kind of finish, but matt papers are recommended.

adding a glaze

One method of preserving prints that are going to be exposed to the elements, is to spray them with a water resistant fixer that will also increase light resistance. Such fixers can either be sprayed on to a print, or brushed on with a paint bristle. The latter works well with textured papers as it adds to finish. Either way, you will now have a print that can survive splashes of water and other environment hazards. Either specialist inkjet suppliers or artists' shops can supply these.

2

3

continuous ink flow

3/ Trine Sirnes Thorne shot this picture on a Canon digital SLR. It's the end of the Ponte Vecchio bridge in Florence, Italy which is filled with jewellers. Trine had printed it using standard inks but then decided to try it with a new set of pigmented inks, which not only produced the strong colouring required, but six months later, still looked as good on the wall as the day it was framed and hung.

When involved in large scale print jobs using an inkjet printer, there is one common complaint – the ink doesn't last very long and it isn't very cheap. It's also a pain in the backside to continually have to change cartridges. Continuous ink flow systems are set up to alleviate these problems, though initially the exercise is more like a craftwork project. A number of companies including Fotospeed and Lyson produce replacement inks, which consist of connecting refillable bottles to the cartridge holder, or placing the bottles outside the printer footprint and running wires to the printer head. Obviously this kind of system is not designed to be plugged and unplugged as the whim takes you. Equally if you are going to be printing monochrome images as well with dedicated black-and-white inksets, then it's time to invest in another printer as the practicalities of switching between the two systems are off-putting to say the least. Once a replacement ink system is airtight, it may need to be vacuum sealed, depending on the system, but all will usually require a specific colour profile for the new inks. The advantage is that printing can continue at will as there is a much greater store of ink to fall back on, you can use specialist inks as well, and refills come in the form of large bottles, cutting costs considerably. When an ink bottle runs out, just refill it from the store.

10 paper types

The world of digital output would be a
pretty ordinary place if the only choice
of paper to print on was gloss or matt.
Fortunately that isn't the case and
those willing to experiment can find
success with extended gamut papers,
those designed for black and white,
textured surfaces and artists' material-
like finishes. The world of output doesn't
end with gloss paper, that's where it
starts. Go discover.

photographers

Mehmet Ozgur
Duncan Evans
John Braeckmans

Mehmet Ozgur of Washington DC, USA used a variety of cameras to produce this image. It is a composition of five elements: two trees, the hill, the cloud, and the background. All but the cloud were taken at Lake Fairfax, Reston, VA, USA. Mehmet had been shooting bare trees for a long time, hoping to find a good use for them. In parallel he constantly shoots for good cloud formations. The day he shot the cloud at sunset, he started playing with these two trees, cloud and the background. The hill was a natural edition.

Mehmet says: 'I was hoping to add a human touch to the image, preferably a jogger climbing the hill. Ultimately, my vision is not complete yet. I hope to convey the unbearable weightlessness of the cloud.'

> For maximum ability to resist fading, an inkjet printer using pigment rather than dye ink is advised.

> Heavier, textured paper stock runs the risk of either soaking up too much ink so that the paper becomes mushy or causing banding effects. It is advisable to cut up a sheet of A4 paper into smaller 6"x4" sections for test prints.

art effect papers

Once you progress beyond the standard glossy and matt papers, there is a whole world of paper stocks waiting for your images. Papers with textures and the feel of an artist's materials all await. While such papers are not cheap compared to regular paper stocks, they can give an extra finish and texture that is more tangible and gives a better effect than simply adding textures digitally and printing on smooth paper. How the paper reacts to your specific printer is largely trial and error, though it is worth checking out websites of the manufacturer to see if there are any recommendations or warnings. Also when magazines do paper tests, the results can be invaluable in terms of discovering which printers the papers are most compatible with. Often, a cheaper route is to purchase a trial pack of papers, containing a few sheets from each range, but at a basic price.

One such range of art-effect papers is Somerset Enhanced (known as Somerset Photo Enhanced in the USA) from St Cuthberts Mill, which distributes papers to the UK, USA, major European countries and around the world. Somerset Enhanced is a 100% cotton mould-made paper which comes in three fantastic finishes – Satin, Velvet and Textured. This is made to the same acid-free archival standards as all their traditional artist papers and is buffered with calcium carbonate to combat acid attack from airborne pollution. It is suitable for fine art photographic images, as the surface texture becomes part of the final print, enhancing the look and feel.

> digital capture
> perspective corrections
> hue/saturation
> unsharp mask
> Durachrome inks
> Somerset Enhanced
 Velvet paper
> print

shoot

This shot by John Braeckmans of Lier, Belgium was taken in mid-summer with a Canon digital SLR and an EF-S 18–55mm lens. He wanted to make a presentation of the freshly restored castle of D'Ursel in Hingene, Belgium.

enhance

Firstly perspective corrections were applied to straighten out all the vertical and horizontal lines, then the hue/saturation was adjusted. Finally the unsharp mask was used to give the final touch.

enjoy

The print was made on an Epson 9600 printer using Durachrome inks and Somerset Enhanced Velvet paper. A fine bronze metal frame was used. John also produced a series of four pictures of the castle for an exhibition.

1/ Because of the wide-angle lens and the relative closeness to the subject, there is a good degree of distortion in the picture.

2/ The selection of art effect paper stocks in the Somerset Enhanced range from St Cuthberts Mill.

3/ With straightened verticals, this impressive structure looks the part on quality paper.

Just because it's an inkjet print, you shouldn't display it in conditions that would damage a painting.

You can contact St Cuthberts Mill on +44 (0)1749 672015 or artistpapers@inveresk.co.uk

3

11 digital effects

Where once the chemical darkroom reigned supreme, now the world is turning to digital. While printing processes in the chemical world can still be said to offer options that mere inkjet output can't cope with, the chemical manipulation and retouching of the photograph have been utterly surpassed by the digital world. Not only is it cleaner, safer and more ecologically sound, digital editing allows unparalleled flexibility and power in creating the kind of picture that you want.

This image was taken by Patrick Loehr, about four blocks from his home. The city of Arvada, in Colorado, USA is a common subject for Patrick as it is an odd place that seems trapped somewhere between the past and the present. Every day Arvada gets a little more contemporary so Patrick frequently walks around with his camera trying to capture its uniqueness before it becomes like everywhere else.

Patrick says: 'I frame the images in a white 16x20 matte with a simple black wooden frame. The image is not centred in the matte, but rather weighted towards the top of the frame. This simple presentation focuses attention on the image.'

photographers

Patrick Loehr
Duncan Evans
Howard Dion
Mike Monette
David Pichevin

2 channel mixer

Layers | Channels
Normal ▾ Opacity: 100% ▸
Lock: ☐ ⌁ ⊕ ⬚ Fill: 100% ▸

Levels 1
Background 🔒

1/ Metering for the sky plunged t[...] tower into darkness.

2/ The image was changed to mo[...]

3/ A curves adjustment was use[...] increase the tonal range of the sk[...]

4/ Gaussian blur was applied to t[...] lower right hand of the picture to [...] knock it back from the tower.

5/ The unsharp mask was used t[...] give the tower sharpness and contrast.

6/ The duotone colour chosen wa[...] Pantone 382C.

7/ The CMYK version of the final image.

duotoning

3 curves

Channel: RGB ▾

Input: 64
Output: 68

Traditionally, duotones have been used to counter the limitations of a printing press when dealing with black-and-white images. Digital images that are greyscale typically use 256 shades from black to white, but a printing press may only have as few as 50 variations in a single ink tank. For inkjet printing, you might be able to use all four ink tanks to get more definition, but it won't produce any better tonal range than the 256 shades. The use of duotones therefore was to add an extra colour ink tank to be used for the highlights or midtones of an image, as well as the black ink for the rest of the image, thus increasing the tonal range in the image. Careful use of the colour of the second duotone could also give tinting to add feeling to the image, without recourse to colour. In Photoshop, duotoning is much more flexible as the base ink can be any colour you like, and the second tone can be as bright or dark as you desire.

shoot

It was a dismal, cloudy day near Perth in central Scotland when I came across this round tower in Abernethy. It is only one of two examples of a Celtic-influenced round tower in Scotland. Suddenly, the sun almost broke through the dense cloud, making for interesting effects in the sky. I fired off a shot on my Fuji digital SLR, metering for the sky as that was where the detail had to be retained. The result was that the sky was recorded, but the tower disappeared into shadow.

4 gaussian blur

Radius: 2.0 pixels

enhance

Firstly the image was converted to monochrome using the channel mixer (2). It also allowed a certain amount of tonal restoration. Then a levels adjustment layer was used to brighten up the ground areas. The sky was masked off.

A curves adjustment layer was then used to increase the tonal range of the sky, with the ground areas being masked off (3). These layers were flattened and the top of the spike on the tower was cloned off as it touched the top of the frame.

The dodge tool at 5% opacity for midtones was used to brighten up gravestones and the side of the tower. Then the building in the lower right was selected with a Freehand marquee. It was feathered by 4 pixels and a 2.0 radius gaussian blur applied to knock it back away from the tower itself (4).

The tower itself was selected, with the marquee line inside the edge of the tower. This was then feathered and Unsharp Mask applied to give it sharpness and contrast (5).

Now the image was converted to greyscale and then again to duotone. Pantone 382C colour was chosen to give it a more otherworldly type effect (6). The image was then converted back to RGB for storage as a TIFF.

5 unsharp mask

Amount: 75 %
Radius: 3.0 pixels
Threshold: 10 levels

Images have to be converted to greyscale mode first, then duotone. They can be turned back into **RGB** when you are finished editing so that you can print using all the ink cartridges on an inkjet.

6 duotone options

Type: Duotone

Ink 1: black

Ink 2: PANTONE 382 C

Ink 3:

Ink 4:

☑ Preview

Overprint Colors...

Custom Colors

Book: PANTONE® solid coated

PANTONE 379 C
PANTONE 380 C
PANTONE 381 C
PANTONE 382 C
PANTONE 383 C
PANTONE 384 C
PANTONE 385 C

L: 80
a: -25
b: 88

Type a color name to select it in the color list.

enjoy

'The Dark Tower', as this image is called, was converted to CMYK for use in this book and the RGB version printed out at A3 on an Epson 6-ink inkjet printer. Both versions were saved as TIFFs. Due to the different colour gamut of RGB and CMYK there are slight differences between the two versions.

7

1

! Be wary of general saturation increases over 25% as they may cause odd coloured pixel artefacts to appear in the photo.

boost colour saturation

In the film world there is a good deal of choice when it comes to colour reproduction. Film stock can be picked to give perfect skin tones, verdant greenery or healthy tones. Velvia is the film of choice for most landscape photographers because of its rich, saturated colours. In digital, colour is the weakest element. Digital cameras are very adept at detecting tonal differences in a very clean and precise manner, but colour reproduction is only one step removed from blind guesswork. As a result, colour, at least on the current generation of cameras, is not the bountiful harvest that Velvia users can reap. On the point-and-shoot camera brigade, where post-production is unlikely, colours have to be pumped up, but the lack of accuracy can produce results entirely unacceptable to the dedicated photographer. The solution then, for digital camera users rather than those scanning film, is enhancement on the computer.

> digital capture
> levels
> curves
> hue/saturation
> unsharp mask
> resized for web
> save as CMYK
> resize & save as TIFF

shoot

This is the ruined castle at Scalloway on the Shetland Islands, taken from the road high above as it winds down towards the little town. A 28–300mm lens was used to capture it, which at f6.3 maximum aperture for the lens meant that either a tripod was required, or a very bright day, otherwise, the shutter speed would not be fast enough and camera shake would result. Fortunately it was the latter case, with clear skies giving the water a blue Caribbean colouring. Unfortunately this didn't show up on the digital photograph, with the colours flat and grim (1).

enhance

The first step was to stretch the tonal range out by using the levels command. The right hand slider under the histogram was moved to where the data began to fully maximise the tones available (2). Then curves control was used to make the highlights brighter and the shadows darker, separating them more from the midtones.

Next the colours could be enhanced, but rather than just increase saturation across the board which can give false results in places, it was better to target them individually. The hue/saturation control was selected and greens selected from the edit menu. The colour picker was then used to select an average green colour from the picture itself, and then the saturation slider was increased by 20%.

This process was then applied to the cyan element in the photo to restore it to the colours as seen on the day (3). Finally unsharp mask was applied to sharpen the photo.

2 levels

1/ The original digital photo does no justice to the real conditions on the day with awful colour saturation and reproduction.

2/ The tonal range was stretched using the levels command.

3/ Hue/saturation was selected. The colour picker was used to select an average green colour from the picture itself and then the saturation slider was increased by 20%. The process was also applied to the cyan content of the picture.

4/ Unsharp mask was used to sharpen the picture.

5/ The completed, enhanced image. Note that the colour of the sea has had to be made bluer for printing in this book because CMYK does not offer the same level of bright cyan that is actually in the RGB version of the picture.

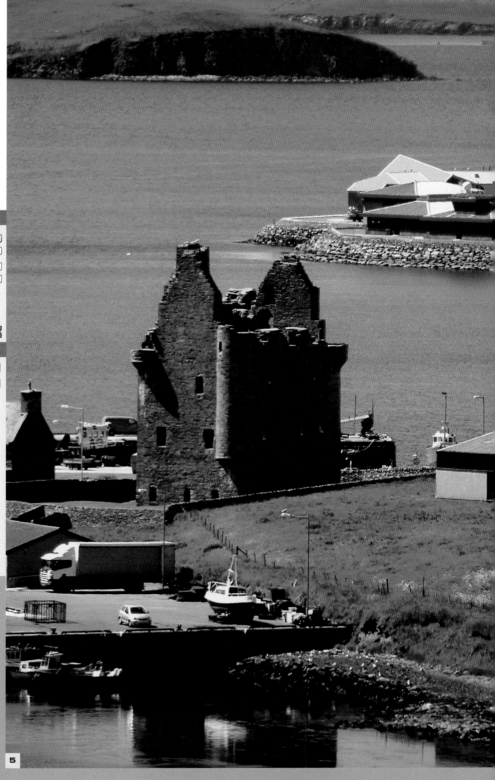

! CMYK does not offer the same kind of saturated colours that RGB does, so if converting to CMYK, check and adjust the image before sending to the printer or photo lab.

3 hue/saturation

Edit: Cyans

Hue: 0

Saturation: +20

Lightness: 0

148°/178° 208°\236°

☐ Colorize
☑ Preview

OK
Reset
Load...
Save...

4 unsharp mask

OK
Reset
☑ Preview

⊟ 100% ⊞

Amount: 71 %

Radius: 3.0 pixels

Threshold: 3 levels

enjoy

The image was resized for use on my website and also saved as a CMYK for publication in this book. The final destination for the image is in a calendar, so it will be resized to fit the available shape and saved as a TIFF file for maximum quality.

5

! Don't overwhelm the
image with the
texture or you will
lose the reason you
wanted to print it in
the first place.

texture effects

An alternative to printing
on art papers with rough
woven finishes, and the
expense that entails, not
to mention the problems
it poses your printer, is to
add textures digitally and
print on your normal
glossy or matt paper. This
also allows you to
combine surface types to
create unusual, and
otherwise impossible,
combinations. The main
advantage though, is the
knowledge that you can
add an extra finish to the
photograph without
worrying about specialist
paper soaking up a
fortune in ink before
turning into a squishy
mess.

> digital capture
> hue/saturation
> unsharp mask
> curves adjustment
> texturizer
> convert to CMYK

shoot

This is a pair of Puffins, huddling into a near vertical cliff face at Sumburgh Head in the Shetland Islands. I shot them with a 400mm lens, using a digital SLR, so the effective focal length became around 600mm.

Using a long telephoto like this requires either bright sunny days to get fast exposures, free from camera shake, or the use of a tripod. This was shot resting on a beanbag on a wall.

1/ The final image, complete with texture, ready to be printed out and framed.

2/ The tweaked, final version of the puffins, before the texture effect was added.

3/ The colour saturation of the original image was enhanced using hue/saturation.

4/ Texturizer was used to create a canvas weave type of effect.

enhance

Like most digital photographs this required the colour saturation to be enhanced with hue/saturation (3). It was also sharpened with unsharp mask and the contrast adjusted with curves. Having good contrast is useful when you add the texture as it makes it stand out more.

This type of picture is ideally suited to a canvas weave type effect so select Filter > Texture > Texturizer (4). The scaling percentage sets how large the effect will be – as this is an effect and not paper, a large number like 200% can be very effective. The relief figure sets how much contrast the effect uses to make it stand out.

! Black and white is ideal for adding textures to, as it is all about tone and texture in the first place.

! Pick a texture type to suit the image. Old, gnarled wood effects over your holiday pictures are just wrong.

enjoy

To be used in this book the image needed to be converted from RGB to CMYK, but unfortunately this colour model is very poor at bright oranges – just the colour of the puffins' beaks. Hue/saturation can help

a little, but there are times when you simply have to accept what you get. However, there is an alternative in commercial publishing and that is to use a fifth colour (in addition to C, M, Y and K) on this particular plate

– this normally applies to covers as it would increase the cost of a book or magazine by an impractical amount. With a fifth colour, bright neon colours, or puffins' beaks, are achievable.

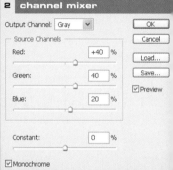

> ! Old people, ruined, deserted buildings or farms all make great subjects for dirty, grainy pictures.

> ! Ensure the grain effect is strong enough to be readily noticeable, otherwise it will be mistaken for digital noise.

1

grainy pictures

If you want to produce grainy, contrasty black-and-white pictures and you use film, it's easy. All you have to do is go and find a black-and-white film that has lots of contrast and offers a high **ISO** like 3200, which guarantees plenty of grain. When shooting digitally, there's no such option – though in my mind camera manufacturers should certainly give you it. Don't be misled into thinking that simply ramping up the ISO on your digital camera will give you a similar, grainy effect. It won't. High digital ISOs produce coloured noise and in most cases, loss of detail. Even once that coloured noise has been converted to mono, the lack of detail will be apparent. Instead, do it in **Photoshop** or your favourite software package.

> digital capture
> crop
> channel mixer
> curves adjustment layer
> grain filter
> channel mixer
> interpolation
> save as **TIFF**
> alternative edge effect

shoot

It was an early evening round the corner from Chinatown in London's west end. The model was wearing a ballgown while I was wielding a digital SLR as we hunted for rubbish and the detritus of modern, city life. The juxtaposition of posh outfit with low-life grime, then turned into a black-and-white, gritty picture would make a photographic statement. Aside from dodging taxis, the problem was that the light wasn't very bright. Good enough for ISO 100, but only with the aperture wide open at f2 on this camera. The focus was placed on the background, to give the model a disconnected feel by being slightly out of focus thanks to the shallow depth of field.

enhance

To concentrate the viewers' attention on the model, the picture was first cropped to remove extraneous detail. Then, it was converted to mono using the channel mixer option. The greyscale box was ticked and the RGB channels adjusted to get the best contrast picture (2).

2 channel mixer

Output Channel: Gray

Source Channels
Red: +40 %
Green: 40 %
Blue: 20 %

Constant: 0 %

☑ Monochrome

OK
Cancel
Load...
Save...
☑ Preview

3 curves

Channel: RGB

Input: 181
Output: 208

OK
Cancel
Load...
Save...
Smooth
Auto
Options...
☑ Preview

> ! Perform high contrast adjustments on the desktop where you will have total control, not as a camera option.

To get the really striking contrast required for the picture the curves tool was needed (3). However, used on its own, the white of the boxes of rubbish had all their detail blown out. The solution was to use a curves adjustment layer. The curve was applied and then the boxes in the layer painted over with black to mask the effect.

Next the grain filter was applied with an intensity of 40 (4). This is very strong, but it is also colour. When the channel mixer was used again to turn this colour noise to mono, the effect becomes more pronounced. As the picture was cropped in the first place, it needed to be resized to make it a higher resolution. The secondary effect of doing this now rather than at the start, was that the grain effect was

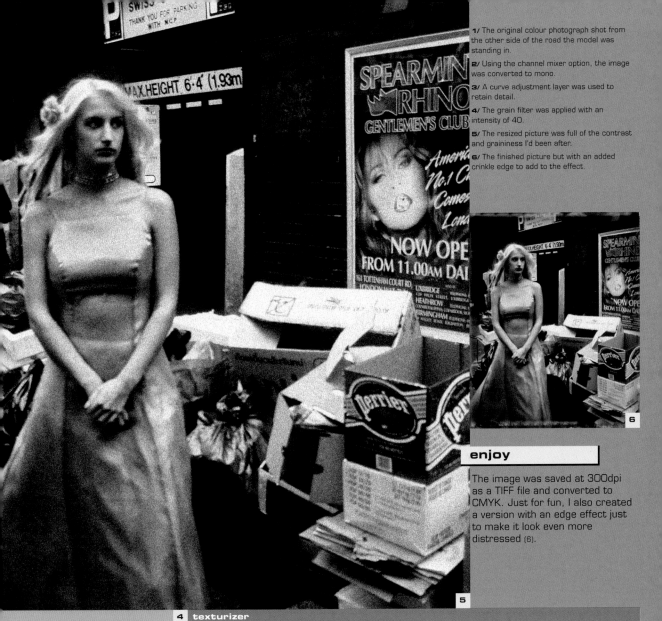

1/ The original colour photograph shot from the other side of the road the model was standing in.

2/ Using the channel mixer option, the image was converted to mono.

3/ A curve adjustment layer was used to retain detail.

4/ The grain filter was applied with an intensity of 40.

5/ The resized picture was full of the contrast and graininess I'd been after.

6/ The finished picture but with an added crinkle edge to add to the effect.

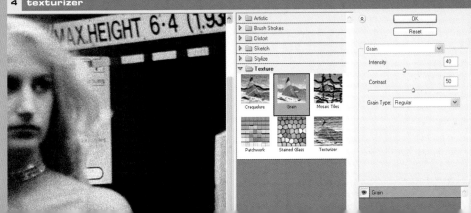

enjoy

The image was saved at 300dpi as a TIFF file and converted to CMYK. Just for fun, I also created a version with an edge effect just to make it look even more distressed (6).

enlarged, giving the photo the feel of a high ISO film stock.

The resized picture is now full of contrast and incredibly grainy and dirty. Just what was wanted (5).

4 texturizer

! Colours can be retained from the original image, or added to a desaturated one for a different feel.

! When saving a completed image from Photoshop or another digitally altered image, save a **TIFF** or **PSD** for print in a dedicated folder and immediately save a **JPEG** of the same image in a web folder for future web use. Staying organised is the key.

spot colour

One of the beauties of digital imaging is that you can mix and match colour and mono imagery from the same original, in a way that is simply impossible using traditional techniques. The advantage of starting out in colour means that you can desaturate completely and add colours, or, as in the case here, selectively remove colour to leave the emphasis on one particular area.

shoot

Mike Monette describes himself as an advanced enthusiast and shot this stunning image of a tulip in his own studio space using a Canon digital SLR with a 17–40mm f4 wide-angle zoom lens.

enhance

There are a number of ways to selectively desaturate an image, but one of the simpler ones is to make a selection around the area you want to remain in colour. If the background is white the selection doesn't have to be that accurate, but be warned that most backgrounds are not pure white and this will show when desaturated. Also, if the brightness of the rest of the background is altered, the edge will be very apparent. The selection separating colour from mono elements should be very accurate. Here it was feathered by one pixel (2).

2 polygon lasso

3 channel mixer

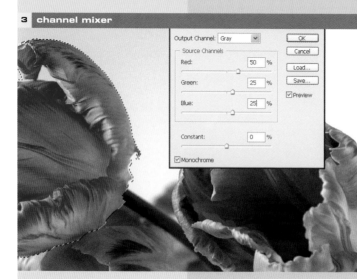

The selection was inverted and the channel mixer used to convert the rest of the image to a more punchy black and white (3). Note that if the percentage values do not add up to 100, the brightness of the background will change, showing up any inaccuracy in the selection where colour borders the white background.

The selection was removed then final hue/saturation and curves contrast adjustments made. The image was then saved as a TIFF.

> digital capture
> feathering
> inverted
> channel mixer
> hue/saturation
> curves
> save as TIFF
> print

1/ The original image shot in colour with a white background.

2/ The polygon lasso was selected and then the edges were feathered by one pixel.

3/ The channel mixer was used to convert the rest of the image to a more punchy black and white.

4/ Hue/saturation adjustments were finally made and then the image was saved as a TIFF.

5/ The final image with desaturated elements, leaving a splash of colour against the monochrome background.

4 **hue/saturation**

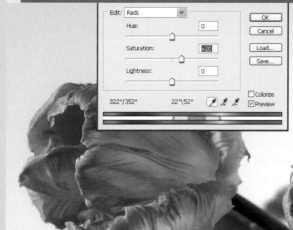

Edit:	Reds	
Hue:		0
Saturation:		+20
Lightness:		0

OK
Cancel
Load...
Save...

322°/352° 22°\52° ☐ Colorize ☑ Preview

5

enjoy

Mike prints his own work on an HP 7960 Photo printer and has sold some prints through word of mouth. He is looking to exhibit some work at local galleries. He has also given various prints to friends as gifts. All his pictures are mounted in simple black metal gallery frames with generous white mats.

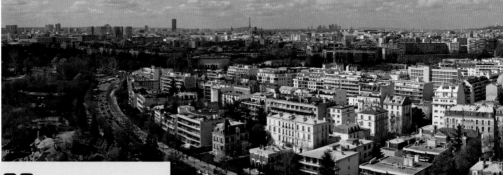

panoramas

While the art of sticking photos together has been well known in the world of film photography, the results tend to look poor, as such, super wide-angle photography has been the domain of specialist film cameras. The advent of digital has meant that individual pictures can be shot and stitched together to form one whole, new, panoramic picture. It can be created using custom panorama software or stitched together in image editing programs like **Photoshop**.

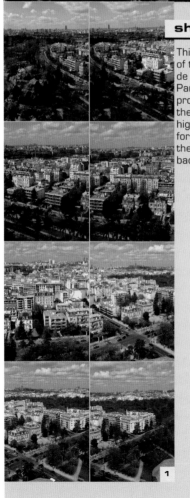

1

> digital capture

> canvas size

> crop

> transform option

> brightness/contrast

> flatten layers

> clone stamp

> curves

> CMYK

shoot

This shot was taken from the top of the rock that is inside the 'Zoo de Vincennes', right outside of Paris. David Pichevin, a professional photographer from the USA shot it using a Canon high-end compact camera. The foreground of the panorama is the town of Saint-Mandé and the background is Paris.

! Use a tripod, first and foremost as it will make things easier.

enhance

There are two ways of creating a panorama in Photoshop. The manual way or using the automated process and then cleaning up the result. The photomerge option in Photoshop couldn't sort the images out, so they were all loaded one by one. The first picture in the sequence

2 canvas size

Current Size: 1.83M
Width: 600 pixels
Height: 800 pixels

New Size: 22.0M
Width: 6600 pixels
Height: 0 pixels
☑ Relative
Anchor:

Canvas extension color: White

3 layers

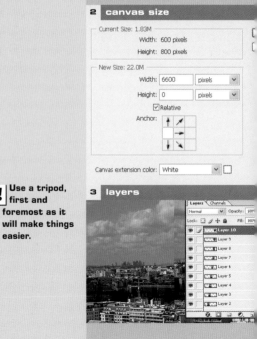

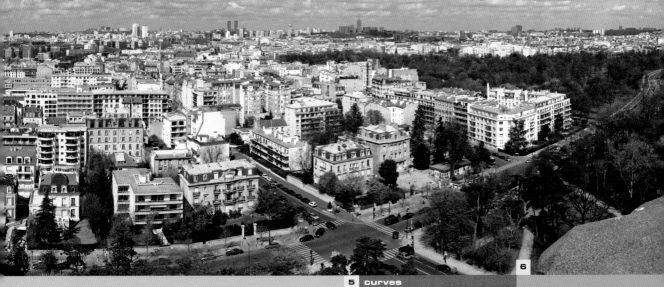

6

was selected and its canvas size increased to accommodate all the other images (2). There were 11 images in total at 600 pixels wide each, so a new canvas was created at 6600 pixels wide.

Each subsequent image was then maximised and dragged into the new panorama. As each one was added, the original image window was closed. The pictures were lined up to make the best join as the process went along (3). When all were in place the extraneous white canvas at the end was cropped off.

As the sequence progressed, distortion started to take more effect so each picture layer was selected in turn and the transform option used to compress or distort them to make them fit better (4).

Then, the brightness and contrast of each section was adjusted so that they all matched each other. After this all the layers were flattened and the clone stamp tool used to match up the joins. Finally, the picture was sharpened and curves used to achieve the final contrast and brightness (5).

5 curves

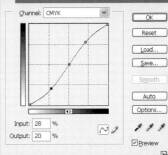

enjoy

David doesn't really make prints any more in the digital age, preferring distribution by electronic means. This picture however was converted to CMYK for inclusion in this book.

1/ There are 11 pictures altogether in the sequence that went to make up David Pichevin's sweeping panorama.

2/ The 11 images were loaded individually into photomerge. The first picture in the sequence was selected and its canvas size increased to accommodate all the other images.

3/ The pictures were lined up to make the best join as the process went along.

4/ Distortion started to take effect so each picture layer was selected in turn and the transform option used to compress or distort them to fit better.

5/ The picture was sharpened and curves used to achieve the final contrast and brightness.

6/ The completed stitched panorama, showing the power of the digital process to create a sweeping image.

4 transform

! If you can, don't use a wide-angle lens setting as this produces more distortion. Zoom in and use more, smaller area pictures to reduce distortion. The less distortion in the sequence the easier it is to stitch.

! Set the white balance on the camera to the same manual setting for each picture as leaving it on auto may cause some to have a different colour than others.

12 frame it up

Just as mounting and framing your picture for display on a wall gives it that finishing touch, so does the digital equivalent, whether it's for display electronically, or to enhance the frame. You can be as creative, subtle or ostentatious as you like – a thin black pencil line border to hold in acres of white, or a baroque, ornate frame to make a statement. Digitally, there is the extra process of edges to be considered as well. Here the effect becomes part of the image, giving it a style and identity it wouldn't otherwise have.

This image was taken at Taos Pueblo in Taos, New Mexico, by Patrick Loehr of Arvada, Colorado. He was trying to capture the harmony of the community, the simplicity of the setting and the deep sense of history and antiquity of the Pueblo. These doors have greeted many generations of people, and he thought they would make the perfect subject.

Patrick says: 'When I photograph on location I always take photos of interesting textures; rocks, dirt, walls, organic material, clouds, etc. for use during digital manipulation. In this image I layered three different textures using various Photoshop blending modes (multiply, colour dodge and overlay). I further manipulated the colour using the levels palette and colour balance palette. I then cropped the image and applied vignette and selective blur effects."

photographers

Patrick Loehr
Duncan Evans
John Peristiany
John Andersen

! Edges eat into photos so make sure that there is enough room around the border for it to work – you don't want to lose anything important.

! Custom designed edges are easy to create if you use layers in your photo editing software.

! If you have added an edge and the picture content looks squashed in, try expanding the edge outwards so that it works on less of the picture, and use the opacity option to show more of the original underneath.

1/ In this original shot the flowers are too close to the right-hand side to use an edge effect.

2/ The canvas had to be expanded and detail was cloned into the new area on the right-hand side in order to do this.

3/4/ In the original there is a distracting bright splash of sunlit colour on the right-hand side, so I took this opportunity to clone over this too.

5/ With the added edge effect this picture now has that little extra that helps it stand out more.

get the edge

Edges, as opposed to frames, are a decorative addition to a photo, that work by eating into the edge of it, rather than adding on to it. A number of software packages come with some rudimentary edge designs and while you can also design your own – see next spread – there are also packages available in their own right that plug into software like Photoshop to offer a huge variety of effects and styles.

shoot

On a sunny day in the garden, I shot these tulips with a 28–300mm 1:2 macro lens on a digital SLR. A digital SLR offers an extended focal length so that the macro reproduction is better than that stated for the lens. In this case it meant I was able to fill the frame with the flowers, while using a tripod to guard against camera shake. Some post-production work was needed including enhancing the colours and increasing the contrast. Then I decided to add a decorative edge effect to the picture.

2 canvas size

Current Size: 17.1M
Width: 2100 pixels
Height: 2840 pixels

OK
Reset

New Size: 18.7M
Width: 2300 pixels
Height: 2840 pixels
☐ Relative
Anchor:

Canvas extension color: Background

3 clone tool

4 photographic edges 6

> digital capture
> curves
> hue/saturation
> unsharp mask
> canvas size
> cloning
> AutoFX edge effect
> save as TIFF
> save as RGB
> save as CMYK
> resized for web

enhance

Edges eat into a photo and as the flowers here are close to the right-hand edge of it, the canvas had to be expanded and detail cloned into the new area from the old. The background colour was selected from the existing colours to form the new background colour of the canvas when it was expanded (2).

As all the background detail was out of focus it was a very simple exercise to clone it across into the new area and just gave enough room for the edge effect to be added. I also took this

The image was resized to 640x480 for use on my website, and also saved as a CMYK file for publication in this book. It's a nice little picture so may be turned into a greeting card or postcard as well.

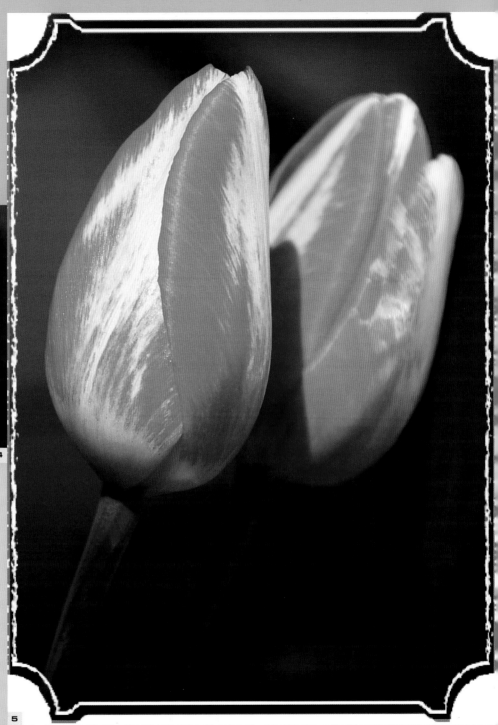

4

opportunity to clone over the bright splash of sunlit colour that is evident on the right-hand edge as well (3/4).

The software package Photo/Graphic Edges 6 by AutoFX was used to add an edge effect. It has a huge selection of effects available so the select edge button was clicked to bring up the catalogue browser, then it was simply a matter of browsing through the 17 volumes of available edges and selecting one (5). Then the image was saved as a TIFF with the effect in place.

5

1

making your own edges

Don't worry if you haven't got a package containing hundreds of fancy edge effects, it's easy enough to make your own. You can even save the edges that you make if you want, though that perhaps negates the freshness that you gain by creating your own. Either way, edge effects can be as simple or complex as you desire and while very ornate effects do require design capabilities, simple ones require little skill and time to produce.

shoot

John Peristiany shot this picture of a young lady using a Nikon film camera with a Nikkor 80–200mm zoom lens. It was scanned and manipulated in Photoshop. What appealed to John in the picture was the portrayal of the ambiguity of youth. How innocent was that look?

enhance

The diffuse glow filter was used to give the image a grainy, bright and ghostly look (2).

Then the contrast was increased and the saturation of the lips enhanced to make the red stand out more. Finally for this stage, the picture was given a tighter crop (3).

To add a customised edge, a blank new layer was created. Then, a selection was made inside the border of the image. This was feathered by 15 pixels then inverted (4).

A small brush with a 40% opacity was chosen, along with foreground colour white. This

3

> film capture

> scan

> diffuse glow

> contrast increase

> saturation

> crop

> new layer

> customised edge

> feathering & invert

> brush

> flatten layers

> print

2 diffuse glow

1/ The original image shot on Fuji Superia film was then scanned and manipulated.

2/ In order to create a grainy effect, the diffuse glow filter was used here.

3/ After increasing contrast and the saturation of the lips, the picture was cropped tightly to create more impact.

4/ A selection was made inside the border of the image which was feathered by 15 pixels and then inverted.

5/ A small brush with 40% opacity was used to brush around the selection on the edge of the photograph.

6/ The completed image with edge effect that adds to the grainy look of the original photograph.

was then used to brush around the selection on the edge of the photo. After a couple of circuits, the size was increased and the opacity set to 60%. Then, the outside of the edge of the photo

was traced with the brush, which ensured most of the edge effect was nearer the picture than away from it (5). The layers were flattened and the image saved.

A smaller brush gives a more scratchy effect, a bigger one a softer effect. The size of the feathering also dictates how sharply the edge effect eats into the photo.

Select Filter View Window Help

All	Ctrl+A
Deselect	Ctrl+D
Reselect	Shift+Ctrl+D
Inverse	Shift+Ctrl+I
Color Range...	
Feather...	Alt+Ctrl+D
Modify	
Grow	
Similar	
Transform Selection	
Load Selection...	
Save Selection...	

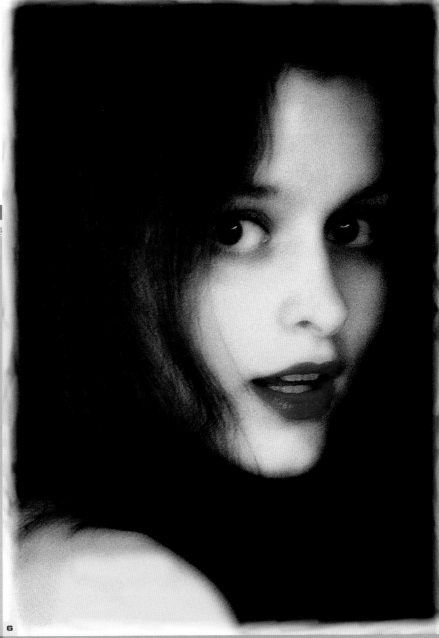

6

File Edit Image Layer Select Filter View Window Help

Brush: 25 Mode: Normal Opacity: 40% Flow: 100%

enjoy

John has only made a 30X20cm print, produced on an Epson 830 printer for his own personal pleasure. The edged version was especially created for use in this book. The final image was converted to CMYK for commercial printing.

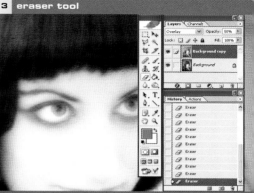

Remember that a frame will add to the overall dimensions of the photograph, in effect making the contents smaller when printing out.

3 eraser tool

adding frames

2 craquelure texture

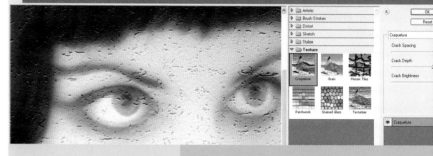

While the easiest way to add a frame to a digital photograph is to put the print inside one, it can often be the case that the selection available in your local photo shop doesn't offer what you want. The alternative is to add a frame digitally, and mount the photo in a clear, frameless photo holder. A digital frame goes on the outside of a photo, unlike edges, which nibble away on the inside of a photo. As such it's easier to get one to fit without cramping the photo because it doesn't affect the content. What you should try to do is match the type of content to the style of frame. Simple frames can be added using Photoshop or Paint Shop Pro, but for more variety it's worth investigating dedicated packages such as AutoFX Photo/Graphic Edges 6, which works as a plug-in to Photoshop, or as a standalone application.

> digital capture
> levels
> channel mixer
> layer mask
> gaussian blur
> spot blur
> sepia toning
> duplicate layer
> craquelure
> texturizer
> overlay blend mode
> eraser
> save as RGB TIFF
> AutoFXPhoto/Graphic
 Edges 6
> frame added
> save

shoot

This photo was shot in the studio on a digital SLR and was then processed to give it characteristics of a 1920s' portrait. The lighting was deliberately kept bland, and diffusion and gaussian blur were used to simulate soft lenses and out-of-focus areas. The colouring replicates the print process at the time.

enhance

Prior to adding the frame the desire was to give the photo some weathered surface texture. A duplicate layer was created and both the craquelure and texturizer – with a burlap weave – filters were applied (2).

Then the blend mode was set to overlay and the opacity reduced to 50%. The eraser tool was set at 20% and used to remove parts of the top layer, so that

4 autofxphoto/graphic edges 6

the creased effect varied throughout the photo (3).

This was saved, then the image imported into AutoFXPhoto/Graphic Edges 6 (4). A frame was selected and added, scaled to fit and the entire project saved again. Minor tweaks were carried out in Photoshop before the image was saved as an RGB file and also as a CMYK file for printing in this book.

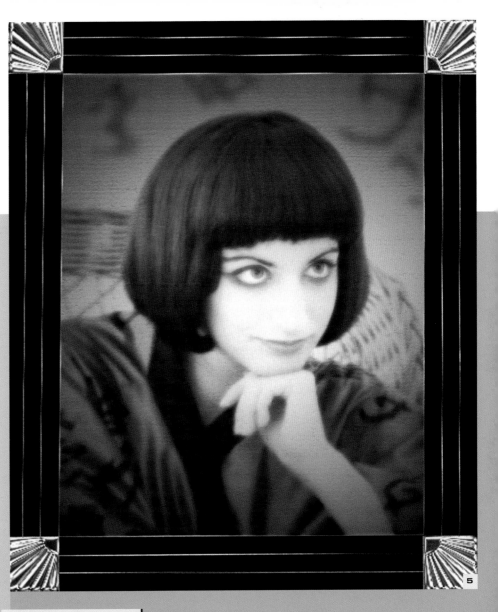

5

enjoy

The original photograph shown here was printed at 300dpi in a magazine feature on recreating classic Hollywood portraits. The version with the added frame was created specifically for this book and saved as a CMYK file. The RGB version was used to print out at A4.

1/ The original photo has already undergone significant Photoshop work prior to this project, but was shot and toned in the style of the 1920s.

2/ To give the image a weathered look, both the croquelure and texturizer filters were applied.

3/ The eraser tool was set at 20% and used to remove parts of the top layer, so that the creased effect varied throughout the photograph.

4/ Selecting a frame.

5/ The completed image now has a slightly skewed frame that can be printed and mounted in a frameless photographic holder.

shoot

This image was shot by John Andersen of Miami, Florida, USA with a Canon consumer digital SLR and a Canon EF 24–70L short telephoto lens. It was taken during a beautiful sunrise over Biscayne Bay in Miami, Florida during early 2004. The sun was just above the horizon and was casting a brilliant orange glow over the water. This pelican was resting in the water as John approached the beach, but unfortunately the only lens with him at the time was the short telephoto. So, he composed the image with the bird in the middle with the aim of cropping in later. As he was framing the image, the bird took flight and he snapped this picture. The splash of water that was captured on take-off really gives a sense of motion to the picture.

creating frames

The alternative to using specialised software packages to create frames for your photos is to make them yourself. This way you can create exactly the effect you are looking for without trawling through 5000 designs on a CD. Creating a simple frame is easy and quick, and can give a digital photo that extra air of quality and style that would otherwise be missing.

enhance

John usually shoots in RAW mode so he opened the image in Capture One software, boosted the saturation by about 7% (1), applied a slight S curve to enhance contrast (2), then cropped and developed the image into a 16-bit TIFF, properly sized for printing. Then he opened the image in Photoshop, cloned out any dust spots from the camera and applied unsharp mask.

To create the frame the original image was opened in Photoshop then a new image approximately two inches bigger in both directions was created – this was the virtual matte (3). The layers palette was selected and the new background layer renamed as matte. The original photo was selected and dragged on to the matte image, creating a new layer. This was renamed as photo.

The photo layer was selected and right clicked. Blending options was chosen from the list to bring up the layer style window (4). A tick was put in the drop shadow box and then the drop shadow style options selected. The distance of the drop shadow was increased so as to make the photo look like it was floating over the frame and matte layer.

To create the frame, the matte layer was selected in the layers palette. Then, using the rectangular marquee tool, a rectangle just smaller than the entire image was made. The selection was inverted and the matte layer selected. A right click on this layer brought up the options dialogue and layer via copy was selected. This new layer was renamed frame and the paint bucket tool selected along with an appropriate colour. The frame layer was

3 layers

> digital capture
> **Capture One software**
> new image
> layer selection
> layer style
> drop shadow
> rectangular marquee
> layer via copy
> paint bucket
> layer manipulation
> text tool

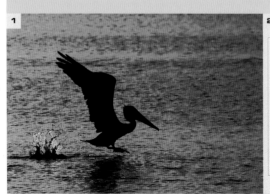

1

2 curves

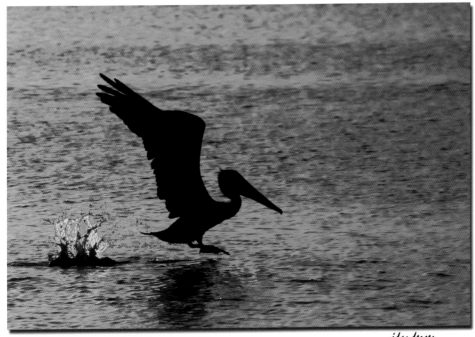

jdandersen

6

1/ The original image after tweaks to the RAW image had been made and the file saved as a 16-bit TIFF.

2/ Capture One software was used to boost the saturation and a slight S curve was applied to enhance contrast.

3/ A new image approximately two inches bigger in both directions was created – this was the virtual matte.

4/ Blending options was chosen from the list to bring up the layer style window.

5/ The frame layer is coloured.

6/ The completed image with black border, a drop shadow effect and a signature, all ready for mounting in a frameless holder.

enjoy

then coloured (5). Next, the drop shadow effect for the photo layer was selected and dragged underneath the matte layer which duplicated the drop shadow effect. The last step was to write in the signature using the text tool.

! **Adding your signature digitally can improve the look of a picture. You can either write it out each time, or save it as a separate file and simply composite it with each new photo.**

John's images are displayed two ways: on the internet, where they are framed using Photoshop and posted in on-line galleries. Also, they are physically printed and framed. This image has been printed at up to 16"x24" using an Epson 4000 Stylus Pro inkjet printer. Because many of John's

photographs are quite minimalistic in a visual sense, he prefers very simple framing. Most of his work is double-matted (white matte board over black to give a black border around the photograph) and framed in simple black metal frames. He finds this framing to be very simple and complementary to most of his images. For viewing on the web the image was assigned an sRGB profile so the colours looked good over the internet on the widest range of devices.

4 **layers style** **5** **layers**

13 storage and display

An area often overlooked in digital imaging is the neat and tidy concern of storage and backup. If you don't store and backup your images properly then before you know it you will have a vast hoard of pictures, taking up hard drive space. You'll have no idea how to sort them out and when your hard drive finally crashes and dies it will be like a mercy killing. Don't let it get to that stage, sort it out, back it all up. Then you can read on about displaying your images the digital way.

Mark Bartosik is a wildlife and nature photographer based in Houston, Texas, USA. A couple of years ago he took a weekend photo trip to Galveston Island in Texas. In the late afternoon he noticed a freshly planted sago palm specimen, which, after planting, shoots all new leaves at once. All of them were an incredible fresh, light green colour. This image was only adjusted a little. Levels were checked then saturation was raised slightly and the image was sharpened. A little part of the top of the final print was cropped to improve composition.

Marks says: 'In my time I fill up the space around me with beautiful animals' worlds and try to document both the unusual behaviour and the natural beauty of the specimens as they pass through their time on Earth.'

photographers

Mark B. Bartosik
Duncan Evans

1/ A Firewire Zip Drive offering 750Mb of storage on every single disk.

2/ The first thing to do is to select the burner type in Nero.

3/ Adding your picture files to the Nero file listing is very straightforward.

4/ In the disc name entry insert something suitable, then set the writing speed for the recording medium.

1

5/ A stack of DVD-R discs is now economical and offers a fantastic amount of storage.

backing up

While the subject of backing up is normally as exciting as redecorating the spare room, when you're talking about digital photographs it takes on a new urgency. Unlike film, you don't have negatives to fall back on, or an original slide you can fish out of a drawer, if disaster strikes. If your hard drive fails, or you get hit by a virus that wreaks havoc with the filing system, then you are in serious trouble. You might be able to retrieve some of the pictures, but it's like pulling the family album from a burning house, frantically snuffing out the glowing embers and seeing what's left. Making backup copies of your digital pictures isn't just sensible, you'd have to be an idiot not to do it.

zip drives

The current generation of Zip drives connect to the PC or Mac via Firewire or USB interfaces and offer up to 750Mb storage per disk. The only trouble is that many people are still using 100Mb Zip disks or the newer format, the 250Mb Zip disk, and those drives will not be able to read 750Mb Zip disks. However, there is little doubt that the current high resolution disks offer an alternative to CDs, if not one with widespread compatibility as anyone can read a CD, but only those with the specific 750Mb Zip drive can read one of its disks. The lower resolution disks offered a decent amount of storage, particularly if you were only shooting lower resolution photos of the family. As a backup medium, the current format at 750Mb offers CD type capacities, with the advantage of simple drop and drag file operations. However, it is more costly than CD.

storing on cd

A typical storage capacity of CDs is 640Mb, although some brands offer up to 740Mb of storage. The unit cost is cheaper than Zip disks, and there is the option of using a rewriteable, or single write, recorder and CD. Prices have fallen so low on rewriteable CD drives – known as CD-RW – that there is little market for the writeable CD drive, the CD-R. The fact that a CD-RW drive can also burn a standard CD-R disc as well means it offers greater flexibility. The disadvantage of using CDs is that the drives have to burn the disc using special software, if the disc is to be uniformly compatible. With single write discs and drives, extra sessions can be added to the disc, but files cannot be erased and when it is full, that's your lot. CD-R discs are very cheap though, and for backing up photos that have been sifted through and sorted out, make a compelling argument.

Fortunately, actually burning a CD is very simple as the following sequence using Ahead Nero 5.5 software shows.

burning to cd

Upon running Nero the first thing to select is the burner type (2). If you have a DVD burner which supports multiple formats then choose either CD or DVD. The next selection is to pick data as the type of disc to burn as this offers the simplest process combined with the wide compatibility – ideal for backing up.

Now it's time to add your picture files to the Nero file

listing. Either click on the add button and use a file browser to locate the pictures to add, or bring up a regular Windows Explorer window and drag and drop the pictures into the Nero interface (3). The pictures and any sub folders are listed along with a graphical indication of the amount of space left on the disc.

Edit the disc name entry to something suitable, then set

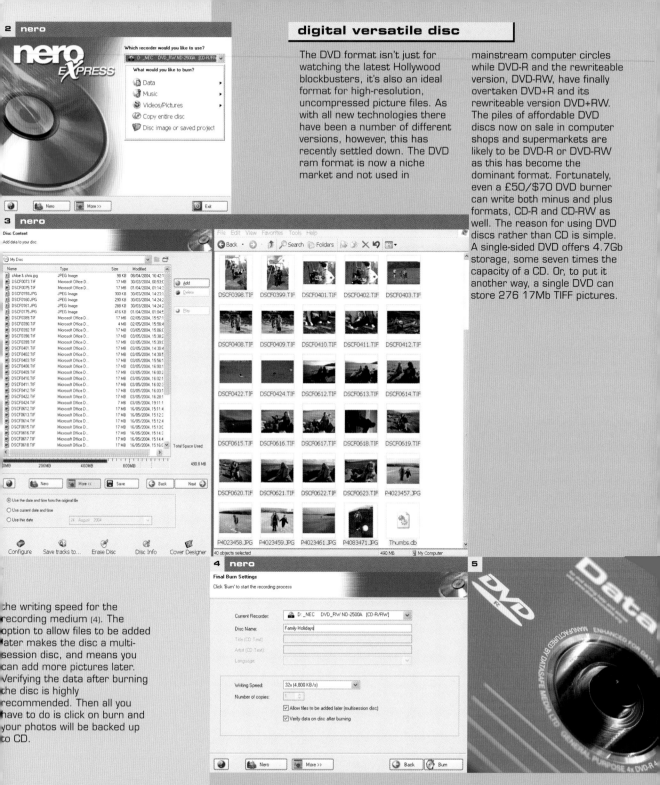

2 nero

3 nero

4 nero

5

digital versatile disc

The DVD format isn't just for watching the latest Hollywood blockbusters, it's also an ideal format for high-resolution, uncompressed picture files. As with all new technologies there have been a number of different versions, however, this has recently settled down. The DVD ram format is now a niche market and not used in mainstream computer circles while DVD-R and the rewriteable version, DVD-RW, have finally overtaken DVD+R and its rewriteable version DVD+RW. The piles of affordable DVD discs now on sale in computer shops and supermarkets are likely to be DVD-R or DVD-RW as this has become the dominant format. Fortunately, even a £50/$70 DVD burner can write both minus and plus formats, CD-R and CD-RW as well. The reason for using DVD discs rather than CD is simple. A single-sided DVD offers 4.7Gb storage, some seven times the capacity of a CD. Or, to put it another way, a single DVD can store 276 17Mb TIFF pictures.

the writing speed for the recording medium (4). The option to allow files to be added later makes the disc a multi-session disc, and means you can add more pictures later. Verifying the data after burning the disc is highly recommended. Then all you have to do is click on burn and your photos will be backed up to CD.

! Bear in mind that the maximum resolution of anyone's screen who views the slideshow is unlikely to be more than 1600x1200, so pictures that are higher resolution are just wasting space. Create smaller versions just for the slideshow to save space.

self-displaying pictures

Creating a slideshow out of a selection of your favourite pictures is an excellent method of both electronic distribution and allowing people to see your work. The only drawback normally associated with slideshows is that the user needs to have a specific player to show it. The solution to this is a brand of slideshow creation programs that turn your pictures, text and even music, into one single file that can simply be clicked on to launch, with no extra software needed. There are many of these programs available, but to show what you can do I have used the very affordable **Pictures to Exe (for Windows)**, which is available to download from www.wnsoft.com in a **30 day trial format**. If you like the program you can register and unlock the full, time unlimited version.

creating a slideshow

Use the browser to navigate to where the pictures are that you want to use. Click on each picture and then the add button in turn to add them to the slideshow in the order you want (1).

Go through each picture and in the comment text box, type in a caption which will eventually appear over the top of the picture (2). Going to the options box now, you can use your own icon for the executable file that will be created and specify what happens when the slideshow ends and how long each picture is on screen for. You can also turn this into a screensaver as well (3).

On the advanced tab you can decide what happens to the mouse button and whether to apply any protection to the slideshow. If this is for general distribution then showing a copyright sign and preventing PrintScreen (PCs) from copying the screen display to the clipboard are to be recommended (4).

On the music screen you can add a music file to play in the background. All major formats are supported including MP3, so simply navigate to the folder where you keep them and add the one you want (5).

On the comments tab you can alter the size, colour, position and alignment of the caption text. As the default options use very small text this needs to be altered. Click on the preview option on the main screen to

2 pictures to exe v4

! If the final slideshow is to be sent to a number of clients via email, use heavier JPEG compression and smaller picture resolutions to reduce the final file size.

3 project options

4 project options

1/ Click on each picture you want to use and then click the add button to add them to the slideshow in the order you want.

2/ To add a caption, type in the text you wish to appear in the comment text box.

3/ In the options box you can specify how long each picture is on screen for.

4/ On the advanced tab you can decide whether to add a copyright symbol to your slideshow.

5/ You can add a music file to play in the background on the music screen.

6/ On the comments tab you can alter the size, colour, position and alignment of the caption text.

7/ On the screen page you decide whether to use the program in a window or across the full screen.

8/ On the effects page you can determine whether to run the slideshow quickly or slowly.

9/ On the message tab you can insert the information you wish to appear at the start of the slideshow.

10/ An example of a slideshow image.

check how the text looks then come back to this menu to adjust if necessary (6).

On the screen page the decision is whether to use the program in a window or full screen. If your pictures are at least 2Mp in size then it looks better to use the whole screen in full-screen mode (7).

On the effects page you can choose whether to use specific transitions, or choose a random transition from a set you specify. The timing can also be altered if you want to make the slideshow run more quickly or more slowly (8).

Finally, the messages tab allows you to enter your personal information in the startup window so that everyone knows who is responsible for this

great collection of pictures. If creating a slideshow as a demonstration of your skills it's important to put some contact information like an email address in (9).

Now all you have to do is click on the create button and that's it! Here the slideshow is shown in action (10).

creating videocd/dvd

We all know the eternal problem of digital imaging – you take hundreds of photos and hardly print any of them out. No problem for you, they're sat on your hard drive and you can print the odd one or leaf through them at your leisure. But what about at Christmas when the relatives come round? Do you really want Uncle Albert dropping mince pie crumbs on to the keyboard or little Johnny being given the opportunity to wheedle about playing his favourite game, shortly before mangling your hard drive? No, of course you don't. You want an easy way of viewing lots of pictures that doesn't involve any danger to your precious equipment. The solution is rather simple. VideoCD or DVD. Both CD and DVD writers are so cheap it's shocking. With one and a handy piece of software, such as Ahead's Nero, you can create a VideoCD or DVD that can be played on a computer or DVD player. Note that some of the very cheap DVD players won't support the VideoCD format, so if that's what you've got, then DVD writing it is. The first advantage of using these media is that they are highly compressed so that you can get far more pictures on view than a simple slideshow using the original files. The second is that they come with menus making it easy for technophobes to navigate through, admiring your photographic brilliance. The other advantage is a practical one – you can photograph like mad at Christmas and then send all the relatives their very own copy on CD or DVD.

1 nero express

making it happen

I set about creating a VideoCD using Nero 5.5, the CD/DVD burning software. While it comes with a file browser, it makes life easier if all the pictures you want are in one place, because then at least you know what is on each CD/DVD that you make (1). This isn't space efficient though. The software was started and VideoCD selected.

Having already put all the images in one place, it made selecting them very easy with the file browser. Note that all different kinds of formats, from compressed JPEGs to hi-res TIFFs, can be mixed and matched because they will all be converted for the VideoCD (2).

As the picture files are added, or dragged and dropped into the creation interface, the software automatically converts the images and creates the levels of menus required. You will be pleasantly surprised to see that the space used is nothing like what the original files take up (3).

Location: BEST OF SHETLAND

Desktop
My Computer
My Documents
Folder details:
BEST OF SHETLAND

File Folder

Modified: 24/09/2004
22:30:26

Name	Size	Type	Modified
backing seal.TIF	11385 KB	Microsoft Office Do...	24/09/2004 22:30:16
bay of garth with border.tif	37656 KB	Microsoft Office Do...	10/05/2004 17:16:23
burn of lunklet2.tif	18481 KB	Microsoft Office Do...	22/09/2004 21:11:39
chloe on beach.jpg	101 KB	JPEG Image	22/09/2004 15:46:14
chloe with seaweed.jpg	365 KB	JPEG Image	08/04/2004 06:21:53
cliffs at exchaners.tif	9696 KB	Microsoft Office Do...	22/02/2004 15:37:54
day into night.tif	15349 KB	Microsoft Office Do...	02/09/2004 12:15:41
exchaners lighthouse.tif	27293 KB	Microsoft Office Do...	20/04/2004 13:21:55
lighthouse at dusk.tif	8961 KB	Microsoft Office Do...	18/05/2004 16:28:53
lighthouse in storm.tif	9337 KB	Microsoft Office Do...	27/02/2004 12:30:20
lunna ness to yell.tif	17874 KB	Microsoft Office Do...	31/05/2004 23:30:36
mum & jake 6x4.tif	7973 KB	Microsoft Office Do...	10/05/2004 17:25:00
Puffins Sumburgh Head.tif	17925 KB	Microsoft Office Do...	28/06/2004 18:11:26
Skipidock Lerwick.tif	17925 KB	Microsoft Office Do...	25/03/2004 12:50:04
st ninian.tif	15895 KB	Microsoft Office Do...	29/04/2004 11:09:49
stoura pund 2.tif	7675 KB	Microsoft Office Do...	21/05/2004 11:51:51

File types: Source Files for [S]VCD (*.wmf, *.tif, *.tga, *...

Add Finished

! **Creating a DVD format disc, rather than VideoCD, will give you a higher resolution picture, but given the limitations of television resolution and display capabilities, it is worthwhile only for those with very expensive TVs, or necessary for those with DVD players that don't support VideoCD.**

1/2/ It doesn't matter if images are a mixture of formats as they will all be converted for the VideoCD.

3/ The space used up on the VideoCD is nothing like what the original files take up.

4/ Nero 5.5 allows you to reorder contents or choose to edit the layout, background or text.

5/ By clicking on text you can change the general headings for each menu page to something relevant to the images.

6/ Set the writing speed to maximum, but do not exceed the maximum speed of the writer itself.

7/ Once the burning process is complete, the VideoCD is ready to be played.

3 space usage

My Video CD (VCD)
Add the video files you want to burn

4 space usage

My Video CD (VCD) Menu
You can change the look of the menu by clicking on the layout, background, and text buttons.

1/3

1. st ninian 2. cliffs at exchaners 3. lighthouse at dusk

4. lighthouse in storm 5. backing seal 6. bay of garth with border

Created with Nero 7-12 >>

Once all the pictures you want have been added, the program moves on to the next stage – showing you the menus. You can reorder the contents or choose to edit the layout, background or text [4].

Having clicked on text, I was able to change the general heading for each menu page to something representative of what the audience would be looking at [5].

Once everything was to my satisfaction I clicked on next to bring up the burning options. If

5 text settings

Text Shadow
Header text: [] Font... ☐
Footer text: [Scenic Shetland] Font... ☑ ■
Item text: [] Font... ☐
Links text: [] Font... ☐

OK Cancel

6 burning options

Final Burn Settings
Click 'Burn' to start the recording process

Current Recorder: D: NEC DVD_RW ND-2500A [CD-R/RW]
Disc Name: My Disc

Writing Speed: Max [1580 KB/s]
Number of copies: 1

you are doing a mass mailout to friends and family, you can specify multiple options here to save having to reload the project. The writing speed should be set to the maximum that the medium you are using can handle, as long as this is not higher than the maximum speed of the writer [6].

Then, just over a minute later, the VideoCD was complete and ready for simply inserting in a computer CD drive or DVD player [7]. The 304Mb of picture files made up 9Mb of disc space when converted to VideoCD. Obviously the pictures are being drastically reduced in resolution but this is intended for display on television, rather than computer monitor, where the display resolution is much smaller, but the display

7 done

Burning Process
Please wait...

23.24.24	_NEC DVD_RW ND-2500A
	JustLink activated
23.24.26	Preparing items
23.24.55	Caching of files started
23.24.55	Caching of files completed
23.24.55	Burn process started at 24x (3,600 KB/s)
23.25.30	Burn process completed successfully at 24x (3,600 KB/s)

Nero Express
ⓘ Burn process completed successfully at 24x (3,600 KB/s)
OK

Done

Copy 1/1

Writing at 24x (3,600 KB/s) Recorder Buffer Level / State
_NEC DVD_RW ND-2500A idle

area conversely much larger. Any jagged edges that would be visible are smoothed out as television sets simply are nothing like as sharp as computer monitors.

! Digital projectors come in three bandings depending on the brightness of the lamp projection – under 1500 Lumens, 1500–2000 Lumens and over 2000 Lumens. The cost starts at under £1000/$1400 for the 1500 Lumens models and rises.

2

digital projectors

There's nothing more traditional than an evening at a camera club, slides placed in a projector and watching weak, and usually badly shot, images being splashed against a white screen. With the advent of digital technologies and the rise of the **PC** as a presentation tool, digital projectors are now in vogue. These work by either taking a video feed from a computer or laptop, in which case the resolution is the same size as the desktop producing the video, or by taking a data feed from a computer, in which case the resolution is set by the projector. All you need to do is either arrange the pictures to be shown into a self running presentation, or manually load each image. With the relevant output from the computer linked up to the input of the projector, the results are then displayed.

A true digital projector is usually specified by brightness but also by image resolution. Some projectors can only display an **800*600** image, more commonly it's **1024x768**. To get a higher resolution usually incurs a much higher premium.

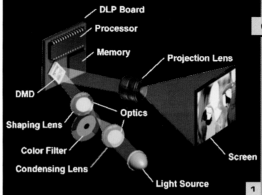

1/ This diagram shows how the Digital Light Processing chip projection system, which uses an optical, micro lens processor to generate the image for projection, works.

1

enhance

The image was cropped and the contrast and colour were increased. Then, unsharp mask was applied to make the rocks stand out more (3).

shoot

This is a close-up photo of part of the Launchy Ghyll waterfall in the Lake District, UK. A tripod was used with an aperture of f22 and an exposure of two seconds to get the water to blur. It was shot while I was on holiday for a week, but later, I decided to use the picture as part of a submission for a Licentiateship with the Royal Photographic Society. The RPS had recently decided to allow LRPS submissions in digital form on CD and the pictures were to be viewed using a digital projector at the assessment.

3 unsharp mask

OK

Reset

☑ Preview

⊟ 50% ⊞

Amount: 40 %

Radius: 3.0 pixels

Threshold: 10 levels

2/ The original image was shot with a tripod and a long exposure to blur the water.

3/ Unsharp mask was used to make the rocks more prominent.

4/ The image needs to be reduced in size to a maximum resolution of 1024 pixels.

5/ The RGB TIFF files were saved and numbered so that the projection software knew what order to show them in.

6/ This is the full size image – converted to CMYK for printing – that was used as part of a successful application for a Licentiateship of the Royal Photographic Society.

The original image was saved at full resolution as a TIFF file. For use in the submission to the RPS the image had to be reduced in size to a maximum resolution on any one side of 1024 pixels (4).

This invariably had the effect of softening the image so Unsharp mask was used again. Then the file was saved as an RGB TIFF with the file name simply as 2.TIF. This was so that the software used on the computer to send the images to the digital projector knew what order to project them in (5).

! If you are showing digital photographs, you really want a minimum resolution of **1024x768** for the projection otherwise too much detail will be lost.

Reduction in resolution for projection will soften an image so remember to apply unsharp mask, after resizing.

appendix

This image called 'Three Sisters' is by Roland DiSabatino of Scotia, New York, USA. He was visiting the Yaddo Gardens, an estate opened to the public in Saratoga, when he spotted these water lilies in one of the fountains. He shot it with a Nikon compact digital camera with a 3x focal length extender. Firstly he used a noise removal freeware filter then cropped the image. He used the channel mixer to give the lilies that yellow colour then applied a custom action filter that softens, darkens and adds a reddish tinge to a picture. Unsharp mask was applied and bright spots were cloned out. Finally, after some selective dodging and burning, he used the sharpen tool to sharpen certain elements in the photo.

photographers

Roland DiSabatino
Rafael Torcida

'Perform the prime sharpening of the image as the last effort and don't be afraid to experiment with Photoshop plug-in action filters to produce new and pleasing effects. When all is said and done, consider that the image is everything. Even Ansel Adams said "if people compared my final works to the original image they would say I cheated."'

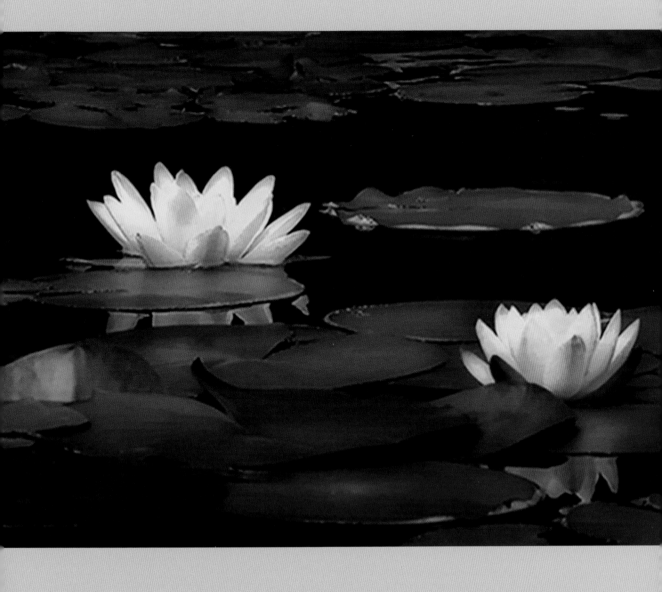

glossary

Adobe RGB 1998: colour profile based on the RGB system with a wide colour gamut suitable for photographic images. See sRGB.

Aperture: the opening to a camera's lens that allows light into the camera to strike the CCD. See F-stop.

Aperture priority: camera shooting mode. Allows the user to set the camera's aperture (f-stop) while the camera calculates the optimum exposure time.

APS: acronym of Advanced Photo System.

Artefact: minor damage or fault on a photograph, usually caused by JPEG file compression.

Automatic white balance: system within a digital camera that removes colour casts in images caused by the hues of different types of light.

Bit: binary digit. Smallest unit of information used by computers.

Bitmap: digital image made of a grid of colour or greyscale pixels.

Byte: a string of eight bits. 1024 bytes make a kilobyte (KB), and 1024KB make a megabyte (MB).

CCD (charge coupled device): electronic device that captures light waves and converts them into electrical signals.

CD-R: a compact disc that data can be written to but not erased.

CD-RW: CD-RWs can be erased and used a number of times.

Chromatic aberration: colours bordering backlit objects. Caused by the poor-quality lens systems used in many compact cameras. Can also affect high-quality optical systems, but only to a limited degree.

CMOS (Complementary Metal Oxide Semiconductor): a light-sensitive chip used in some digital cameras and scanners instead of CCDs. CMOS chips are cheaper to develop and manufacture than CCD chips, but they tend to produce softer images.

CMYK: abbreviation for cyan, magenta, yellow and black – the secondary colours from which colours can be derived. CMYK is used to reproduce colours on the printed page and has a narrower gamut than RGB. See RGB.

CompactFlash: type of memory card with the interface built in.

Compression: process that reduces a file's size. Lossy compression systems reduce the quality of the file. Lossless compression does not damage an image. See JPEG.

Digital image: a picture made up of pixels and recorded as data.

Digital zoom: process that simulates the effect of a zoom by cropping photos and enlarging the remaining image. Reduces image size. See Interpolation and Zoom lens.

Download: process of transferring data from one source to another, typically a camera to a computer.

Dpi (dots per inch): measurement of print density that defines the image size when printed, not its resolution.

DVD: Digital Versatile Disc. High capacity storage medium like CD, but offering six times the space.

DVD-R: Most common type of recordable DVD disc. While multi-session compatible, data cannot be erased.

DVD-RW and DVD+RW: Erasable and re-recordable versions of DVD.

Dynamic range: the range of the lightest to the darkest areas in a scene that a CCD can distinguish.

Electronic viewfinder: a small LCD display that replaces optical viewfinders in some digital cameras.

Exposure compensation: adjustment applied to a photograph to correct exposure, without adjusting the aperture or shutter speed.

Exposure value (EV): measurement of a photograph's brightness.

F-stop: a camera's aperture setting. A high f-stop number means the camera is using a narrow aperture.

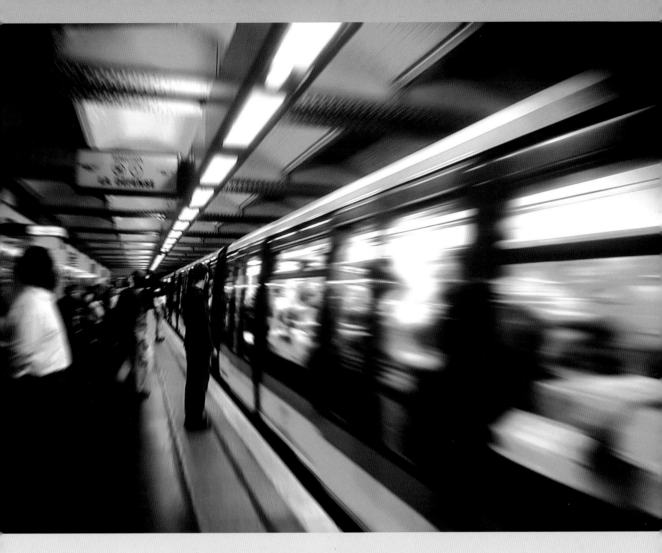

File size: a file's size is determined by the amount of data it contains.

Image-editing software: program used to manipulate digital images. Also known as image-processing, image-manipulation, photo-editing or imaging software.

Image resolution: number of pixels stored in a digital image.

GIF: Graphic Interchange File. Common internet graphic format, used for banners and icons where few colours are required.

Ink jet printer: printer that sprays fine dots of ink on to paper to produce prints.

Interpolation: a process to increase an image's resolution by adding new pixels. This can reduce image quality.

JPEG (or JPG): file format that reduces a digital image's file size at the expense of image quality.

K/s: kilobyte per second. A measurement of data transfer rates.

Kilobyte (k or KB): unit of computer memory. Equal to 1024 bytes.

LAB colour: Colour mode consisting of lightness channel and two colour channels, A covering green to red, and B covering blue to yellow colours.

Laser printer: printers that print documents by fusing toner or carbon powder on to paper surface.

LCD (liquid crystal display): small light display. Lit by running a current through an electrically reactive substance held between two electrodes.

'Stress Day' by Rafael Torcida of Madrid, Spain. Rafael is very interested in capturing urban scenes such as this one. Notice the sense of movement you feel when you look at this image.

LCD monitor: small, colour display built into most digital cameras. Allows the user to preview/review digital photos as they are taken.

Lithium-ion (or Li-ion): powerful rechargeable batteries. Not affected by the memory effect. See Ni-Cd.

MAh (milliamp hours): a unit of measure to describe a battery's power capacity.

Mb/s: megabyte per second. A measurement of data transfer rates.

Megabyte (Mb or MB): unit of computer memory. Equal to 1024 kilobytes.

Megapixel (Mp): a million pixels. A standard term of reference for digital cameras. Multiply the maximum horizontal and vertical resolutions of the camera output and express in terms of millions of pixels. Hence a camera producing a 2400 x 1600 picture would be a 3.8Mp camera.

Memory Stick: Sony's proprietary solid state storage media.

Memory effect: the decrease of a rechargeable battery's power capacity over time.

Microsoft Windows 98/Me: home user operating system used on PCs. Now superseded by Windows XP.

Microsoft Windows NT: the Microsoft operating system designed for businesses using more secure file handling and access.

Microsoft Windows 2000: a Windows NT based system used for businesses.

Microsoft Windows XP: the current direction of Windows. This version is based on the NT kernel but designed for home users.

Microsoft Windows XP Professional: version of XP for home users, professionals or small businesses.

Microdrive: a miniature hard drive offering large storage capacities that can be used in digital cameras with a CompactFlash Type II slot.

MultiMedia Card: type of storage media used in digital devices.

Ni-Cd or Nicad (nickel cadmium): basic type of rechargeable battery. Can last up to 1,000 charges, but can suffer from the memory effect. See Memory effect.

NiMH (nickel metal hydride): rechargeable battery. Contains twice the power of similar Nicad batteries. Also much less affected by the memory effect. See Memory effect.

Optical viewfinder: viewfinder that delivers image of the scene either directly, or via mirrors, to the user, without recourse to electronics or an LCD.

Outputting: process of printing an image or configuring an image for display on the internet.

PC card: expansion card interface, commonly used on laptop computers. A variety of PC cards offer everything from network interfaces, modems to holders for digital camera memory cards. Some memory card readers use PC card slots (or PCMCIA cards).

PC sync: socket on a camera that allows the camera to control studio flash systems.

Pen tablet: input device that replaces a mouse. Moving a pen over a specially designed tablet controls the cursor.

Photoshop: industry-standard image manipulation program produced by Adobe.

Pixel: tiny square of digital data. The basis of all digital images.

Pixellation: effect when individual pixels can be seen.

Plug-in: software that integrates with a main photo-editing package to offer further functionality.

PNG: Portable Network Graphics. A file format commonly used for images used on the internet. Can be defined in anything from 8-bit to 48-bit colour.

Printer resolution: density of the ink dots that a printer lays on paper to produce images. Usually expressed as dpi (dots per inch), but note that this is not the same thing as the dpi of an image.

RAW: this file format will record exactly what a camera's CCD/CMOS chip sees. The data will not be altered by the camera's firmware (images are not sharpened, colour saturation is not increased, and noise levels will not be reduced).

RGB: additive system of colour filtration. Uses the combinations of red, green and blue to recreate colours. Standard system in digital images. See CMYK.

Secure Data (SD): a type of solid-state storage medium used in some digital cameras.

Shutter priority: camera shooting mode. The user sets the camera's shutter speed, while the camera calculates the aperture setting.

SLR: Single Lens Reflex camera. Has the advantage that the image it shows through the optical viewfinder is the one that the camera sees through the lens. Digital SLRs are much faster, more responsive and more powerful than compact digital cameras.

SmartMedia: type of storage card used to store digital images. Very popular digital camera format, now replaced by x-D Picture Card format.

sRGB: common, but limited colour gamut, profile of the RGB system. Most commonly used in digital cameras. See Adobe RGB.

Thumbnail: small version of an image used for identifying, displaying and cataloguing images.

TIFF: image file format. Used to store high-quality images. Can use a lossless compression system to reduce file size, without causing a reduction in the quality of the image. Available on some digital cameras as an alternative to saving images using the JPEG format.

TTL (through-the-lens) metering: a sensor built into a camera's body that uses light coming through the lens to set the exposure.

USB 1.1 (Universal Serial Bus v1.1): external computer to peripheral connection that supports data transfer rates of 1.5Mb/s. One USB 1.1 port can be connected to 127 peripherals.

USB 2.0 (Hi-speed USB): a variant of USB 1.1. Supports data connection rates of up to 60Mb/s. USB 2.0 devices can be used with USB 1.1 sockets (at a much reduced speed), and USB 1.1 devices can be used in USB 2.0 sockets.

VideoCD: the forerunner to the DVD video format. Lower resolution than DVD video but is used with standard CDs. Can be played on PCs.

WYSIWYG: acronym of 'what you see is what you get'. A term for a computer interface that outputs exactly what is seen on screen.

xD-Picture Card (xD Card): memory card format that has been developed by Toshiba, Fujifilm and Olympus. Designed as a replacement for SmartMedia.

X-sync: the fastest shutter speed at which a camera can synchronise with an electronic flash.

Zoom lens (Optical zoom): a variable focal length lens found on most cameras. Used to enlarge images. Compare with Digital zoom.

John D. Andersen

John D. Anderson is the son of a photographer and grew up watching his father work in his darkroom. First a hobby and subsequently a dedicated business called Images by JDA, John's photography is of fine art nature. He displays his work around Florida through fine art festivals and on his website. John has progressed from film to digital and currently utilises Canon's 1D Mark II digital camera.

Pages 20–21, 70–71, 122–123

www.imagesbyjda.com

Nina Indset Andersen

Based in Oslo, Norway, Nina didn't get her first SLR until early 2002. In the summer of 2003 she replaced it with a Canon EOS 10D, and that's when she really got hooked. She had never worked in a darkroom, but now took charge of how her pictures looked. Her main interest is taking pictures of children and macro photography, but she does a little bit of everything. More of her work can be viewed on her website.

Pages 42–43

www.eyesondesign.net

Roland DiSabatino

A mechanical engineer, Roland liked photography from a young age, but never pursued it until he bought his first digital camera from eBay in 1999 to post photos of the things he was selling. He later found some photo sites on the Internet and stumbled on to PhotoBlink. This rekindled his interest. Roland is fascinated by this art and keen to learn and explore the medium. He usually goes out to shoot pictures on the weekend and since discovering Photoshop, he has realised that there is no end to the possibilities that exist.

Pages 134–135

rdisabat@nycap.rr.com

Dirck DuFlon

Dirck currently lives in Florida, USA. From the age of 12 he started following in the footsteps of his photographer mother, Barbara V. C. DuFlon. His interests seem to run primarily toward nature and landscapes, but he loves dabbling in just about every style. He still shoots the occasional black-and-white film or colour transparency, however, digital has opened up a whole new world for Dirck, largely because of its accessibility and immediate feedback.

Pages 86–87

www.pbase.com/dirck
dirckdf@yahoo.com

Mark B. Bartosik

Mark, from Houston, Texas, USA has had an interest in photography since childhood, but could never afford to pursue it until the advent of digital photography. He has taken some college photography courses but prefers to learn from books and even more by his own experimentation. For the last six years, photography has become a life to Mark. In his spare time he tries to document both the unusual behaviour and the natural beauty of animals.

Pages 124–125

www.mbbphotography.com

Cris Benton

Aerial photography aligns nicely with some of Cris's previous interests. He has combined his love of photography with his knowledge of flying radio-controlled sailplanes and the internet. He is currently learning html authorship, desktop publishing and digital image manipulation. He's delighted by both natural and built landscapes, so documenting these is an ideal Sunday afternoon pursuit from Cris's base in Berkeley, California, USA.

Pages 58–59

http://arch.ced.berkeley.edu/kap

John Braeckmans

John is a fine art photographer based in Lier, Belgium. His work is characterised by a unique and highly graphic style. The use of stunning colours and eye-catching views are typical in his photography. His pictures have received numerous national and international awards and honours. Additionally, his images are represented in many private and corporate collections and his prints have been exhibited in galleries all over the world.

Pages 34–35, 96–97

www.braeckmans.com
john@braeckmans.com

Howard J. Dion

Howard Dion lives in Pennsylvania, USA with his wife. For the last ten years he has primarily focused on street photography, capturing people from all walks of life at work and at play. His goal is to encapsulate the very essence of people in a simple and straightforward way. By combining digital photography and technology as a means of creative expression, he has been able to find his own voice using his high key white-out technique.

Pages 104–105

hjayd@comcast.net

Alec Ee

Alec is based in Singapore and has been working for more than 20 years in the Asian Pacific basin for multinational corporations. This has allowed him to travel and indulge his passion for photographing different cultures and people. He shoots with a multi-perspective approach and loves creating travel shots with a fine use of colour and artistic impression.

Pages 10–11, 30–31, 75

www.elanist.com/alec

Tiago Estima

Tiago Estima is a 26-year-old software engineer living in Lisbon, Portugal. He has been very interested in photography for some years now. He started with film but now is into digital photography. To describe his work is not easy. He likes to discover interesting perspectives in relatively common scenarios and create images from little details. Nowadays he's more interested in landscapes and people, and he tries to maintain some aesthetic coherency in all his work.

Pages 84–85

http://estima.home.sapo.pt

Duncan Evans LRPS

Duncan Evans works from the Shetland Islands, Scotland. He has 18 years' experience editing computing and photographic titles and has five photography books to his credit. Currently he undertakes contract magazine publishing and works as a landscape and fine art portrait photographer.

Pages 4–5, 13–19, 22–23, 26–27, 32–33, 39, 41, 44–45, 54–55, 62, 68–69, 82, 89, 95, 100–103, 106–109, 116–117, 120–121, 126, 132–133

www.duncanevans.co.uk

Ceri Jones

An amateur photographer living in Berkshire, UK, Ceri's interest in photography started at an early age of around 14 years. His first camera was a Zenith E SLR and he developed B&W darkroom skills in his parent's garage. By the age of 18 his interest in photography evaporated – probably because of costs and various student distractions. In 2001 his wife bought him a digital camera and his interest in photography was reignited.

Pages 78–79

http://homepage.ntlworld.com/ceri.jones7/

Detlef Klahm

Detlef lives in Langley, British Columbia, Canada, and has a website dedicated to his photography. You can find more of his images on the internet.

Pages 6–7

www.paintwithlight.net
paintwithlight1@hotmail.com

Miguel Lasa

Miguel is based in Hartlepool, UK. A digital artist and passionate enthusiast, he creates traditional-looking digital images, but with sensible post-production to enhance their visual appeal. Often the best work is that which goes unnoticed.

Cover

www.miguel-lasa.smugmug.com

Patrick Loehr

Patrick, a Colorado-based artist, is drawn towards utilising new technologies for creative expression. Currently his artistic pursuits are focused on the manipulation of photographic images. His goal is to express a unique visual impression of the world, not to record what the eye sees. Digital photography is simply the tool he can use to paint with.

Pages 98–99, 114–115

www.loehrgallery.com

Catherine McIntyre

Catherine McIntyre is a digital artist living and working in rural Scotland. She creates magazine editorial, book and CD cover illustrations. She also pursues her own personal work, a selection of which appears in a monograph, 'Deliquescence', published by Pohlmann Press in 2000. Her work has been published in magazines and books worldwide. She is currently working on a new book of digital artwork.

Pages 62–63, 65

http://members.madasafish. com/~cmci/

David Pichevin

David Pichevin is a photographer based in the USA. David started photography as a hobby at the end of 2001 and has been obsessed with it ever since. David is one of the new generation of photographers who has never owned or used a film camera. He has used several digital cameras from a simple 'point and shoot' through to the latest Canon DSLR camera.

Pages 112–113

www.pichevinphoto.com

Nick Ridley

Nick Ridley started photographing pets professionally some nine years ago and is now established as one of the UK's leading dog photographers. During the summer he travels the country taking images of dogs taking part in agility, flyball, obedience and working tests. He has built up an enviable reputation for producing action-stopping pictures which are viewed and printed on site from a custom-built trailer. He has written two books: How to Photograph Pets and How to Photograph Dogs.

Pages 56–57

www.nickridley.com

Jean Schweitzer

Jean Schweitzer is French and has been living in Denmark since 1990. Buying an Olympus C3000 digital camera and developing a back problem gave him the opportunity to shoot everywhere at anytime and from any angle. He learned very quickly with digital technology that every mistake could be corrected, allowing for more experimentation. He read somewhere that to learn photography one has to take pictures and take pictures and take pictures. He did and still does so, every day, an average of 50 to 150 photos.

Pages 50–51

www.cliclac.dk

Mustafa Gündüz Soyusatici

Mustafa gave up teaching due to health reasons and is now working in the transport industry. He has never been trained in art/photography or associated fields, but wishes he had been. His interest all started when he saw the works of Andre Kertesz and Andreas Feininger. Their work fired the Australia-based photographer's passion for capturing images. For a brief period he did some work for the food industry, but being an amateur photographer is his driving force.

Pages 24, 29

mgunduz@bigpond.net.au

Mike Monette

Mike has had an interest in photography since his teenage years but has only really developed his skills since the introduction of digital SLRs. He works in Toronto, Canada as a network engineer and pursues his interest in photography on an advanced amateur/semi-professional basis in his spare time. His subject interests are varied, but his main interests are photo collages and nature photography.

Pages 110–111

mike.Monette@rogers.com

Mehmet Ozgur

Mehmet Ozgur of Reston, Virginia works out of Washington, USA. A hobbyist since the early 90s, he has spent his time looking at nature's elusive beauty. Almost all his images are taken with 35mm film cameras and until recently all his images were printed in traditional darkrooms. Nowadays, almost all his pictures are manipulated and printed digitally. He is currently working as a MEMS (micro-electro mechanical systems) engineer.

Pages 92–93

mozgur@mems-exchange.org

John Peristiany

John is a part-time photographer based in Paris. Since childhood, he has remained in awe at the possibility of capturing a moment on film and interpreting it to his own vision. He feels that portrait and model photography add a new challenge as it depends largely on the interaction with one's subject.

Pages 118–119

johnperi111@hotmail.com

Trine Sirnes Thorne

Trine Sirnes was born in Norway in 1965. She started shooting digital in 1999 and most of what she knows about photography and the digital darkroom is self-taught and learned by attending different photography forums online. Over the years Trine's photos have been both published and awarded numerous times. She specialises in natural portraits, close-ups, abstracts and digital art, using a Canon EOS 300D primarily with a Canon EF-S 18–55mm and a Sigma EX 180mm/f3.5 lens. On October 4th 2004, she became a mother to a wonderful girl, Nemi.

Pages 52–53, 66–67, 91

www.SirnesPhotography.com

Rafael Torcida

Rafael is from Madrid in Spain and works as a software developer, although his real passion is photography. He explores many areas of photography, such as landscapes, street photography, abstract photos and is also interested in heavy digital alterations. In this image-saturated world we live in, his philosophy is to always try and find a different perspective.

Page 137

www.rafatorcida.net
rtorcida@terra.es

Daryl Walter

Born in Aldershot, UK, in 1965, Daryl's been a keen photographer for about 20 years. He initially started taking pictures of the places he visited on hiking and climbing trips and developed a more general interest in photography over the years. He finds the photographs of Ansel Adams, Galen Rowell, and Don McCullin an inspiration and after recently switching to digital from film, is finding the lower running costs and overall freedom to experiment very exciting indeed.

Pages 35, 80–81

digidog@ntlworld.com

acknowledgements

Thanks go to Brian Morris for giving it the go ahead and to Natalia Price-Cabrera for all her hard work. I'd like to thank Sarah Jameson for picture research and Bruce Aiken for his sterling layouts and designs.

The various companies who helped with information, products and artwork have my gratitude. So, thank you very much to:

Ashley Ollet of Canon
Shelley Byfield of Epson
Catherine Frood of St Cuthberts Mill
Jan Herlinger of Fotospeed
Stephen Martinson of Lyson

On a personal level, my appreciation goes to my wife Kerry for essential feeding and support and to Nibbler, a very small black-and-white cat, for demanding attention regardless of deadlines.

Finally, to all those photographers who supplied pictures and information, despite not knowing what ends I was going to put them to, my thanks to you all.